Flower Snowflakes

Stress Relief Coloring Book

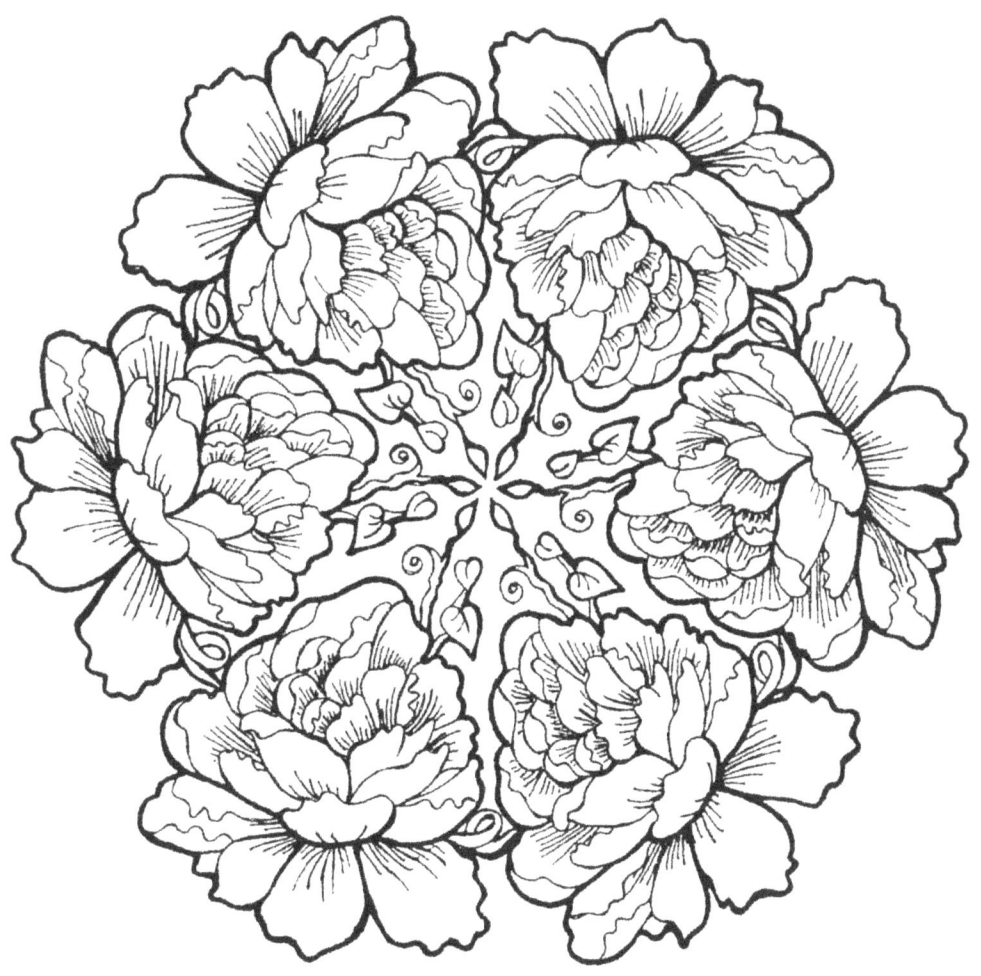

A book of over 30 hand-drawn flower snowflakes and designs.

Marie Scott & Dawn Andrus

Copyright 2016 by Marie Scott & Dawn Andrus. All rights reserved. No part of this book may be reproduced without written permission, except for personal home use.

ISBN - 13: 978-1537484037
ISBN - 10: 1537484036

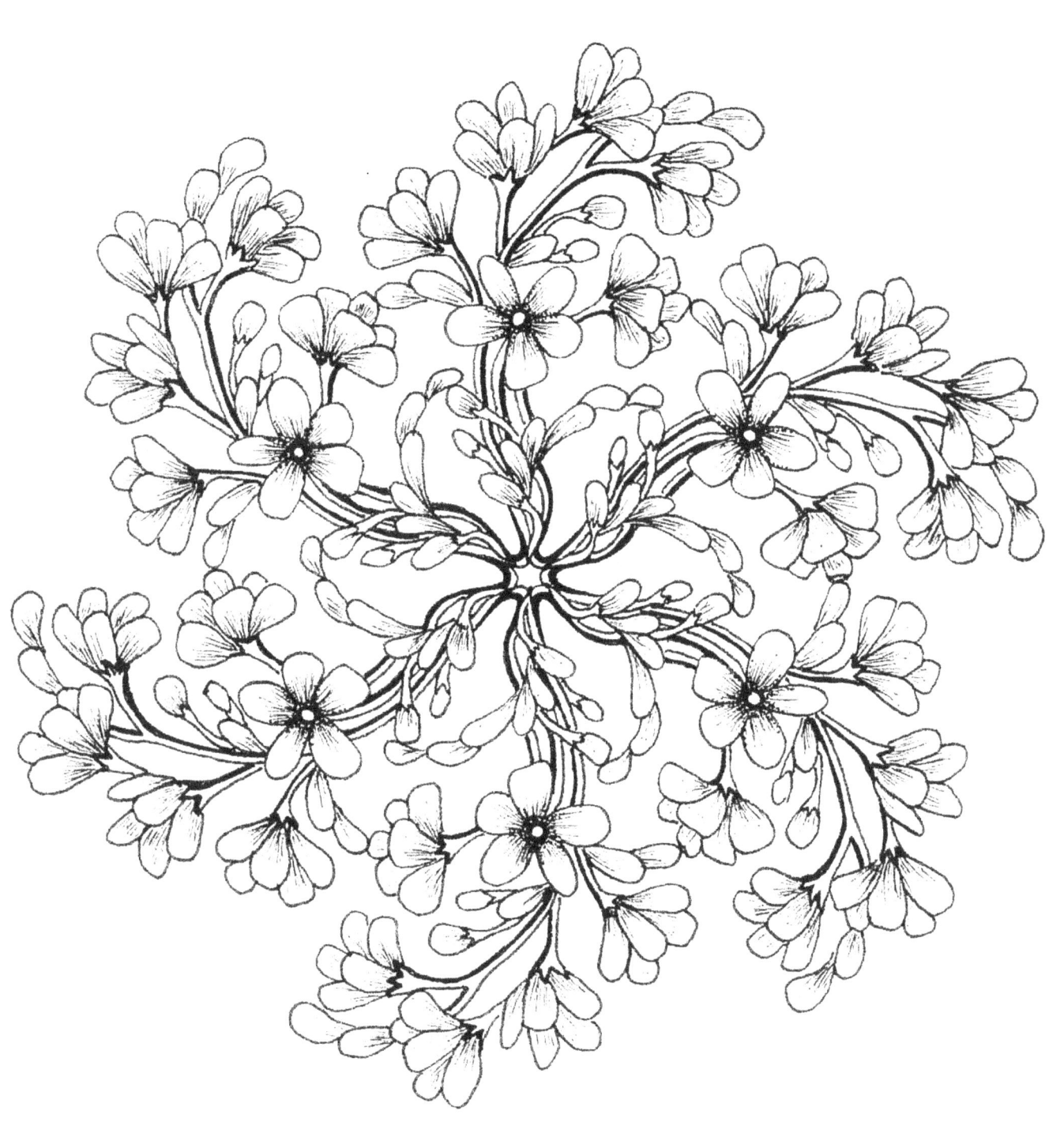

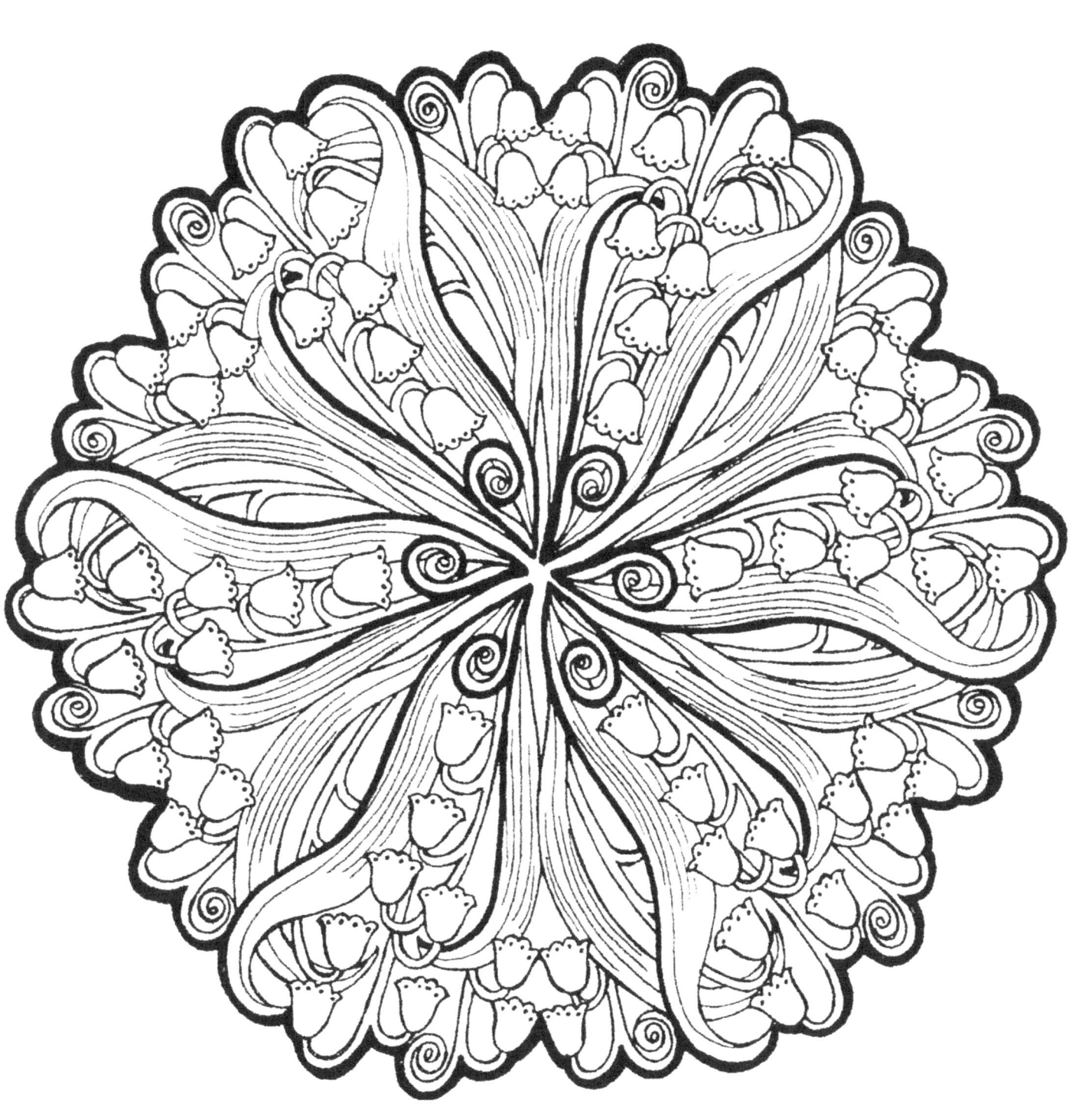

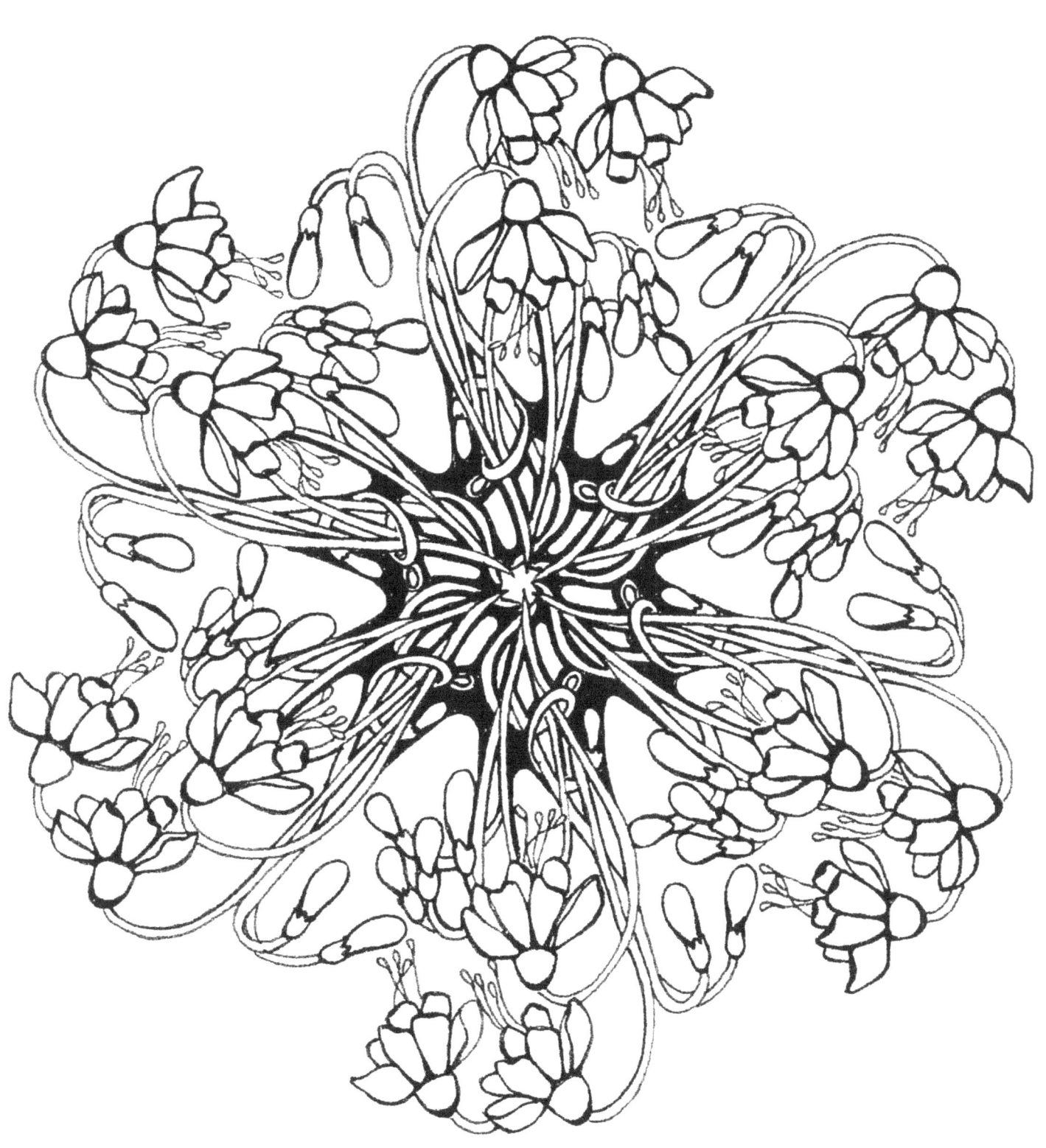

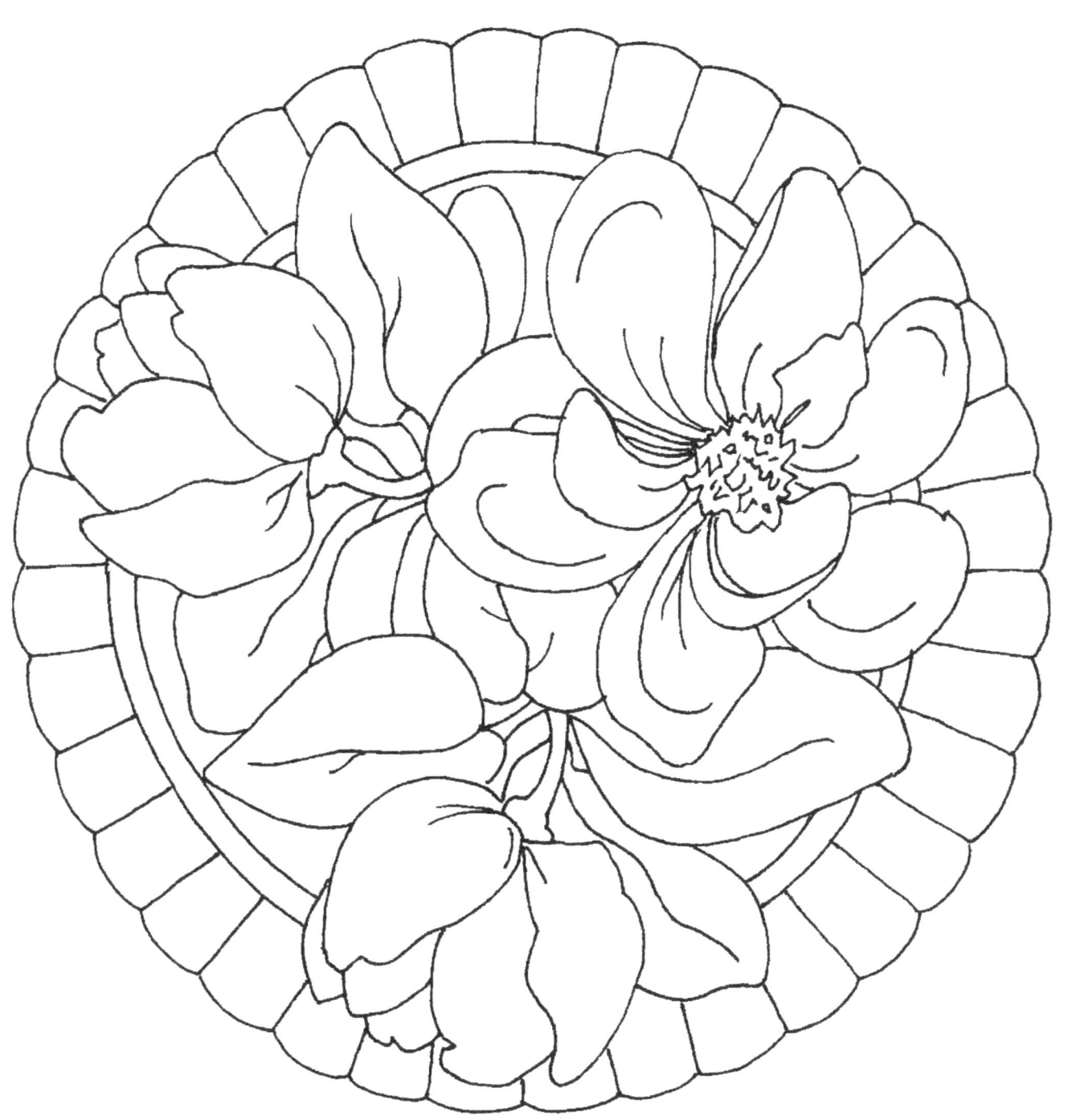

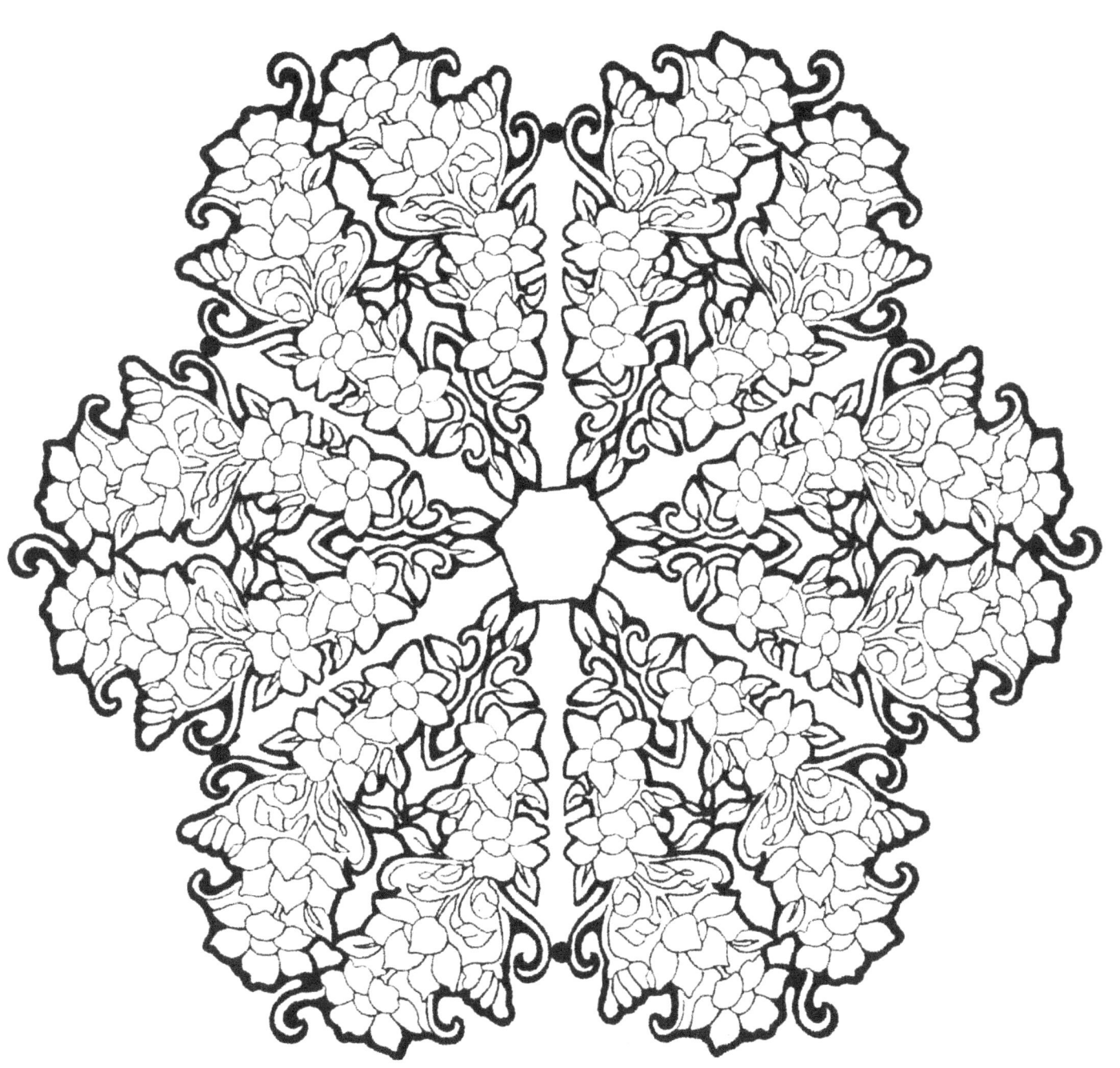

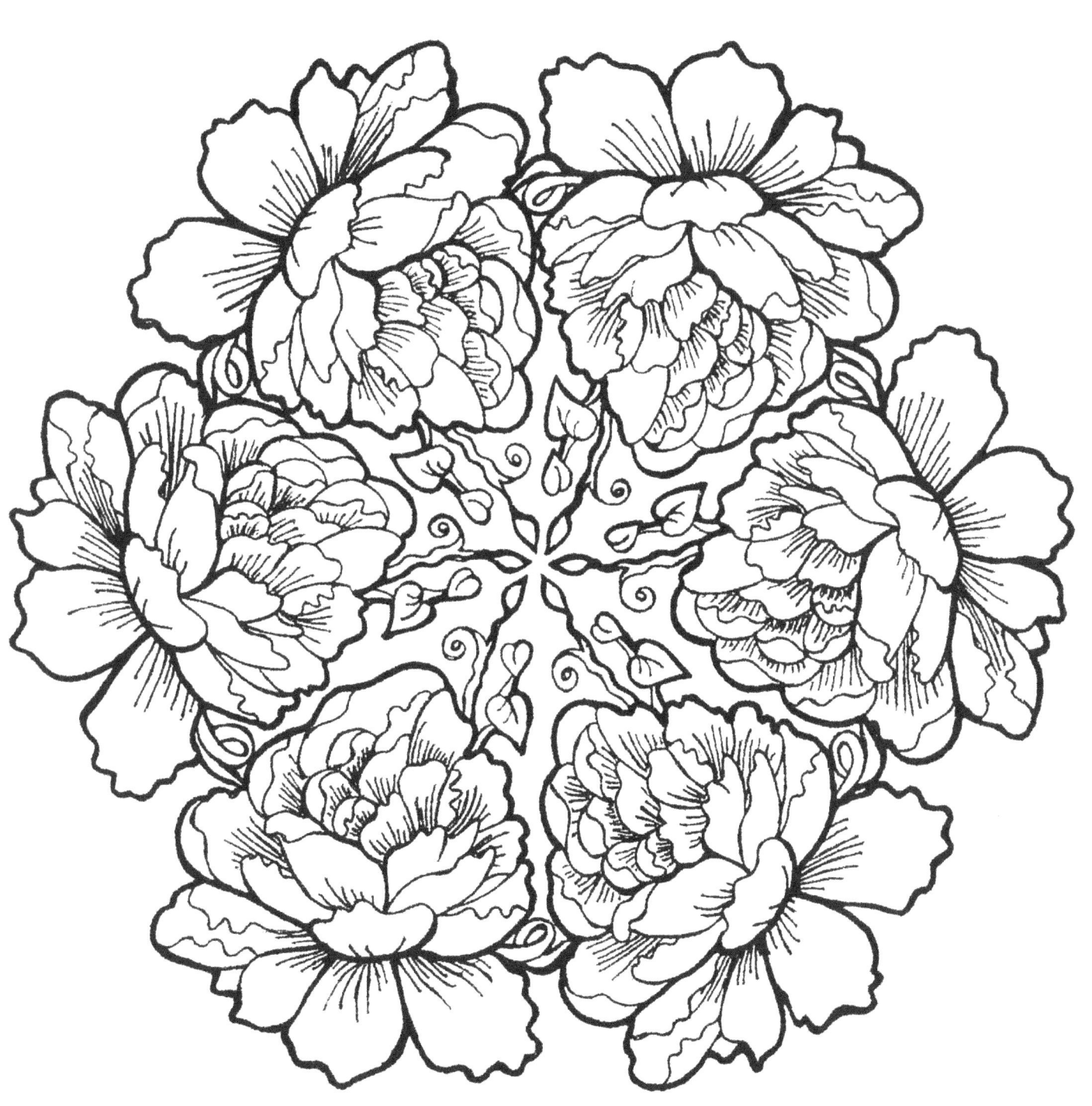

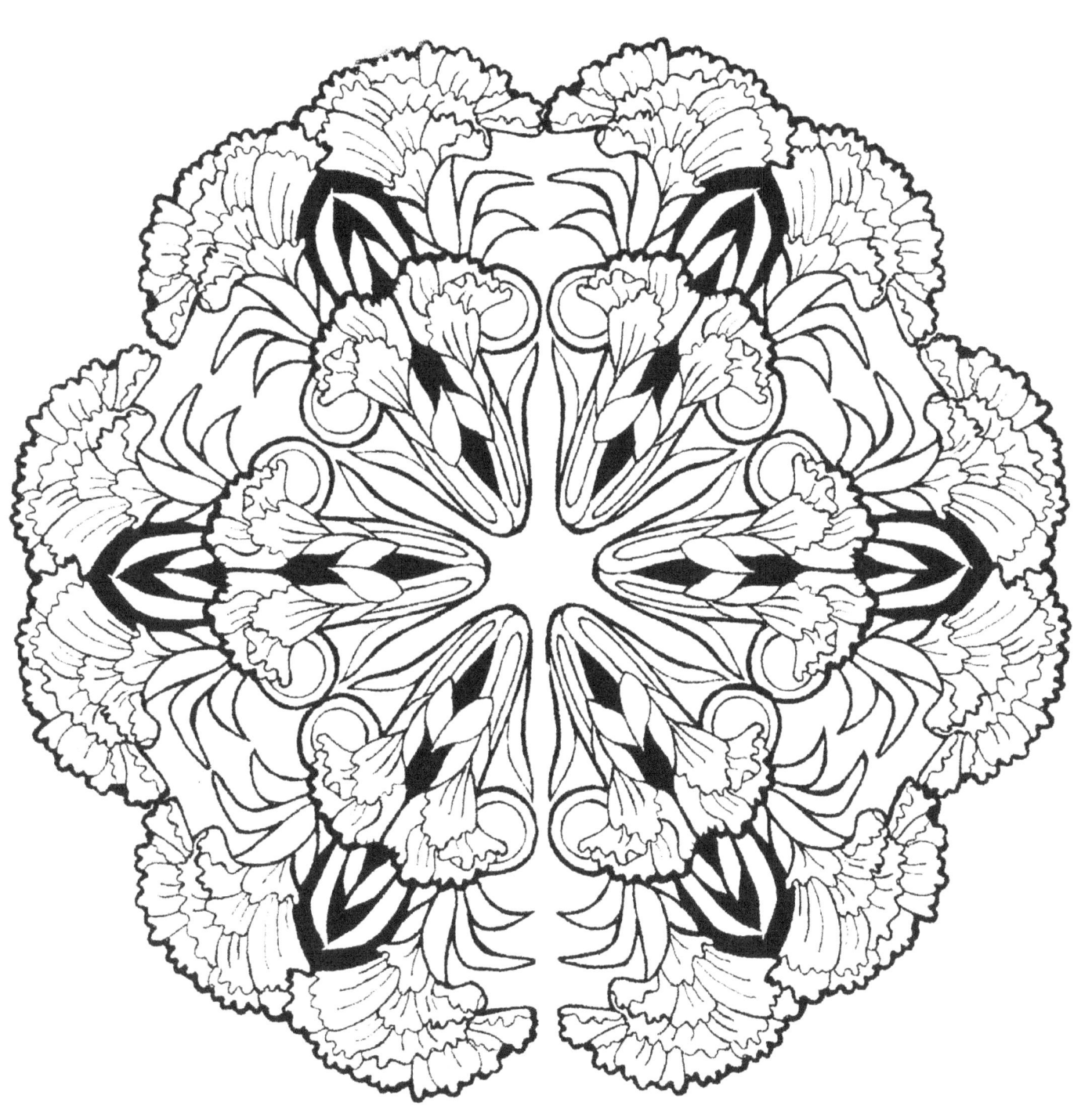

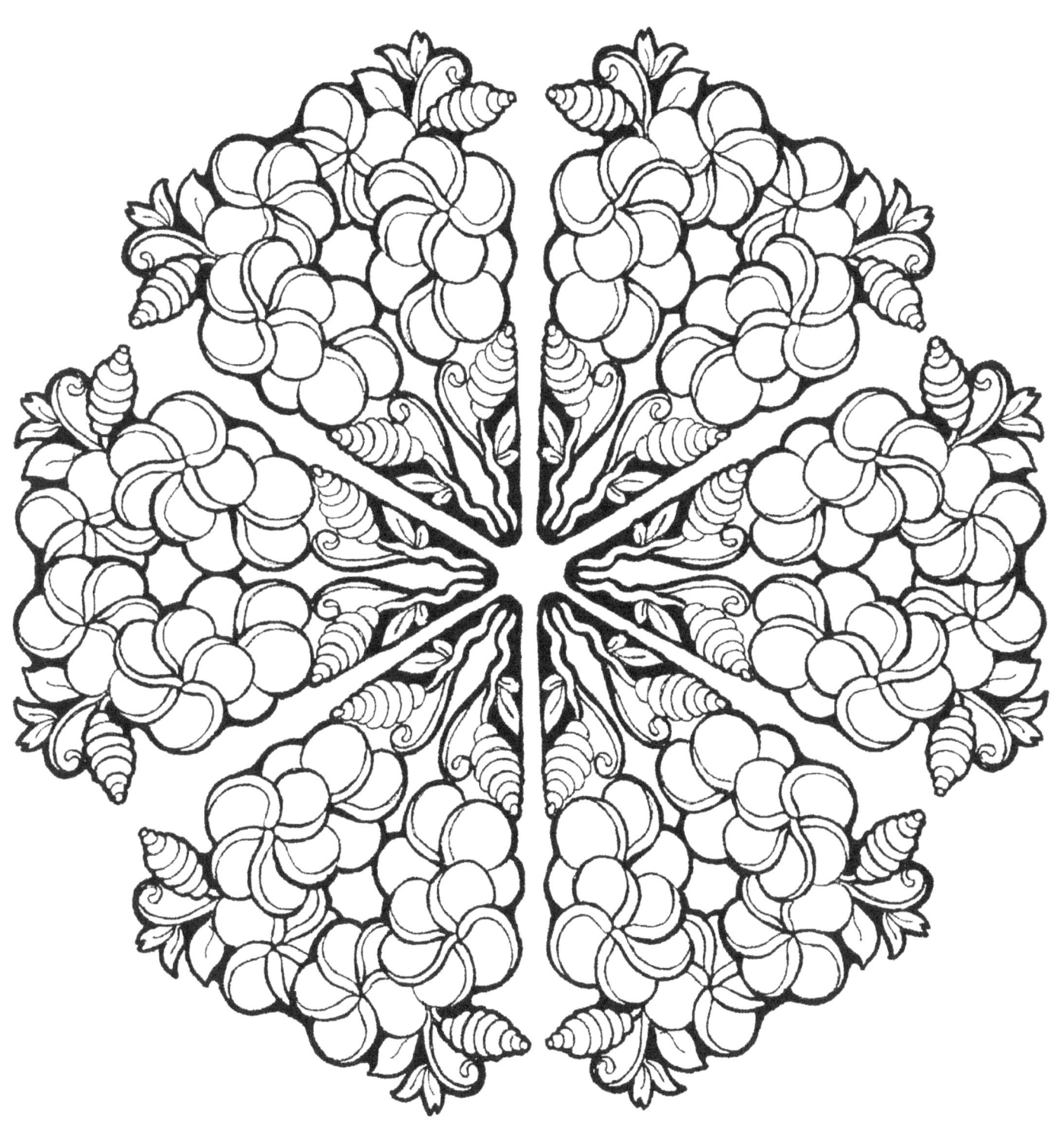

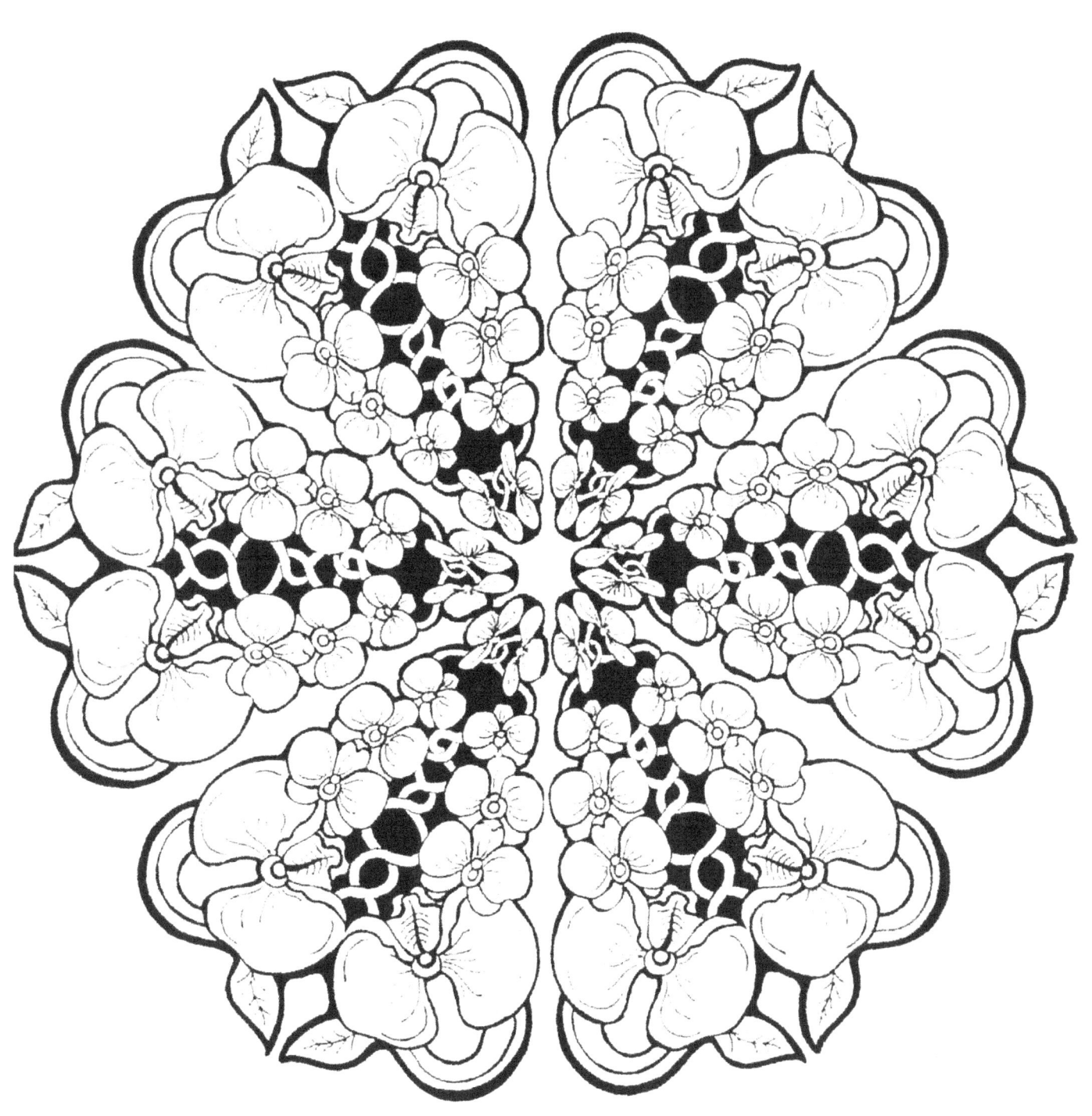

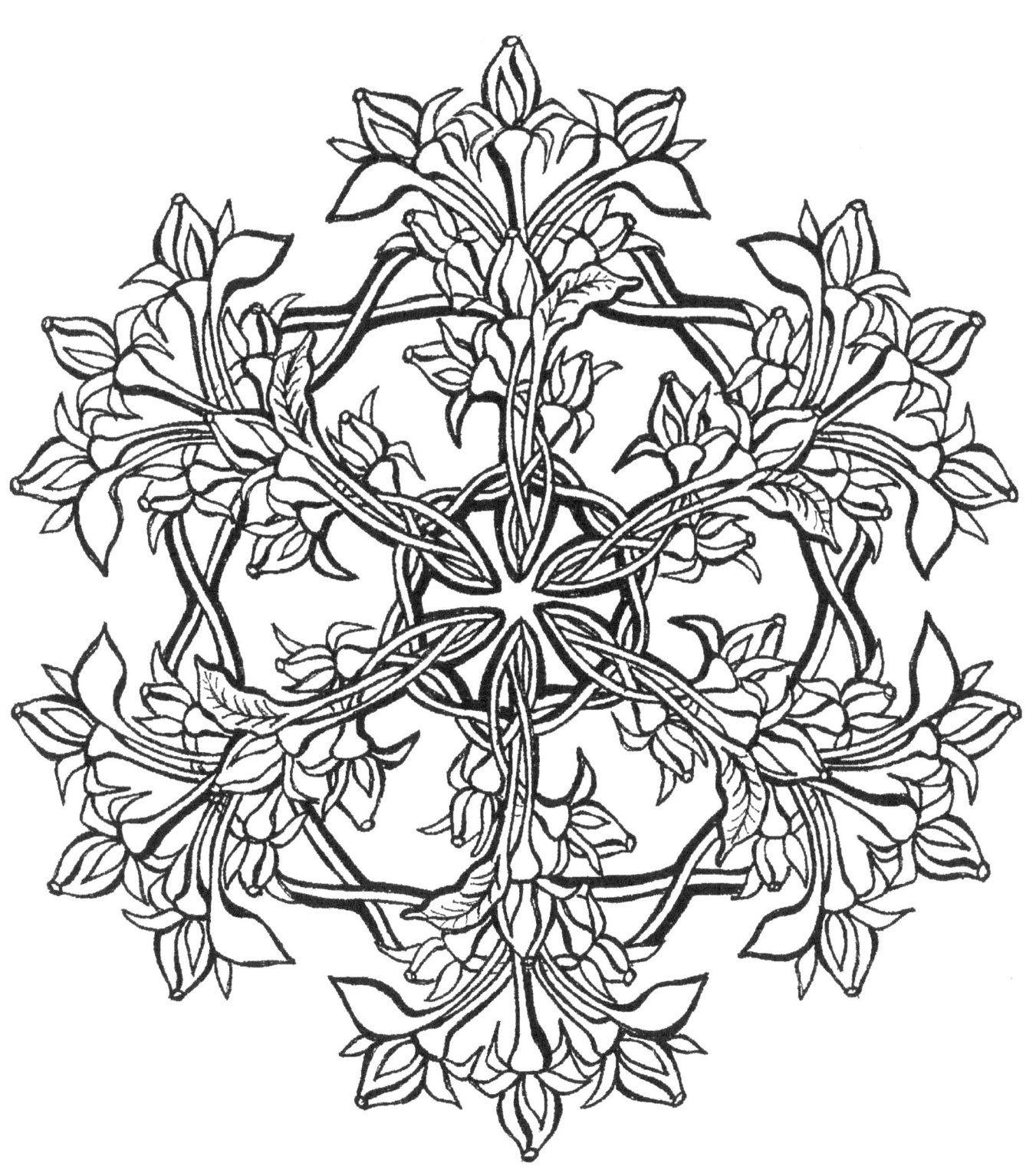

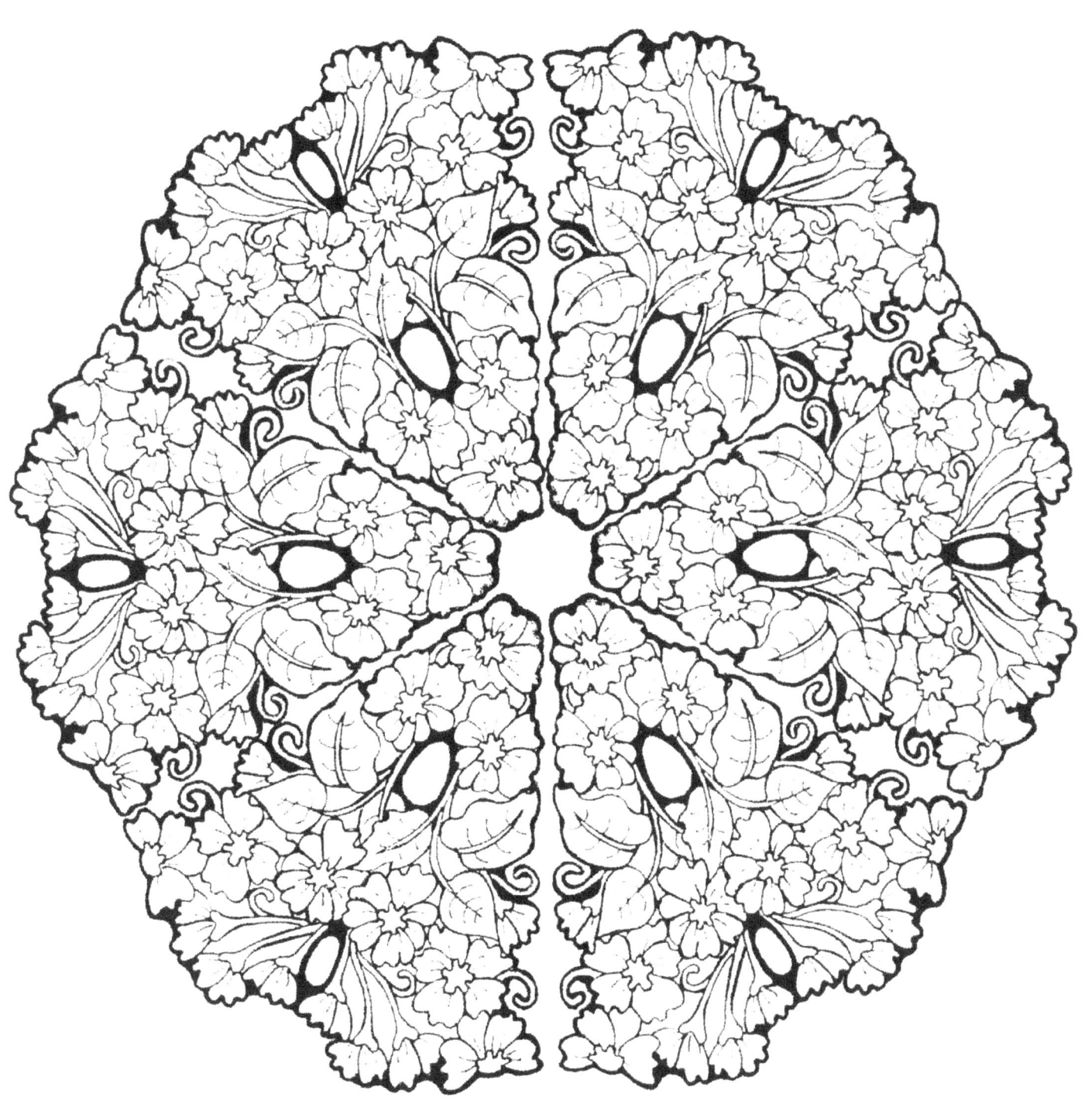

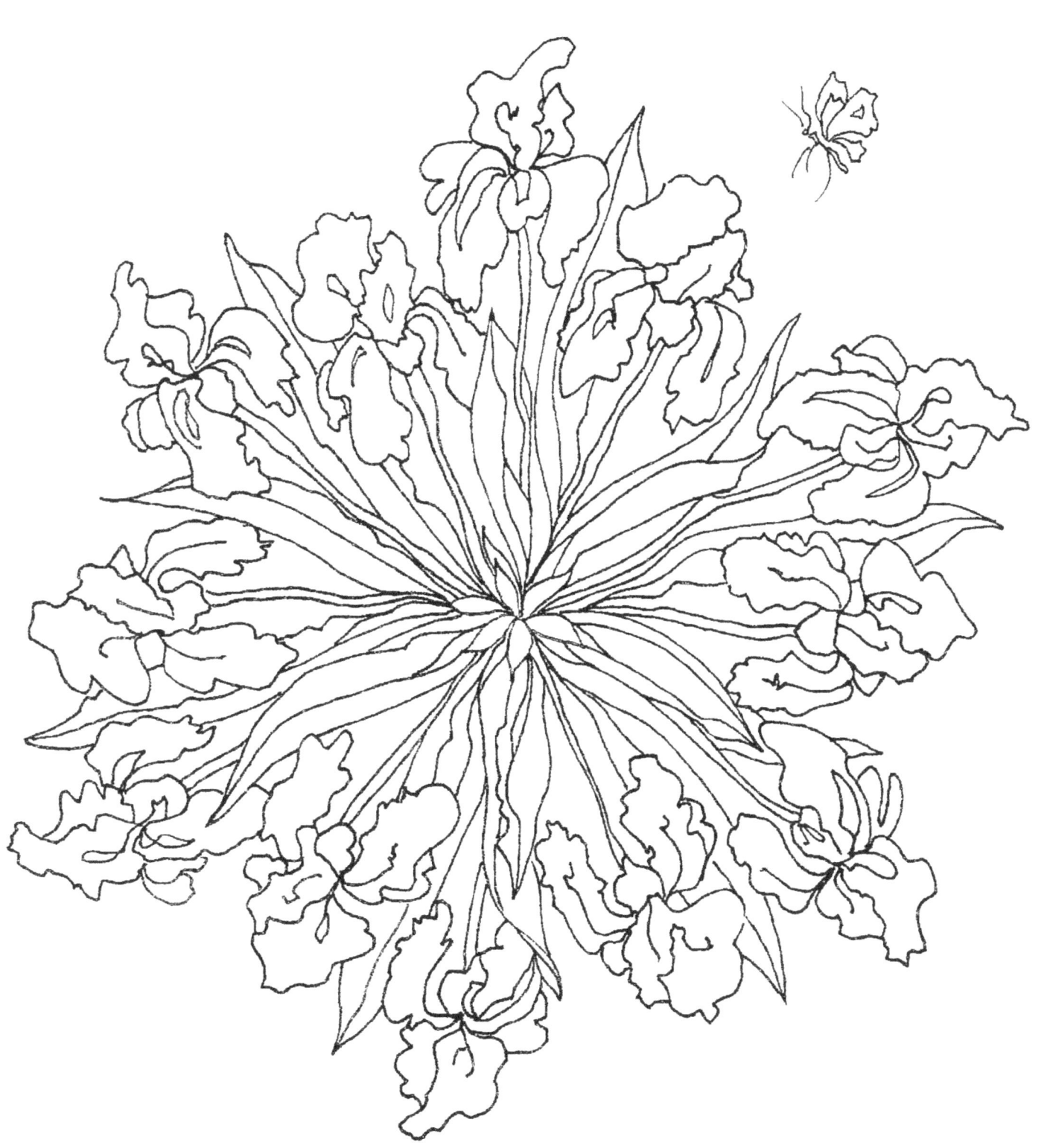

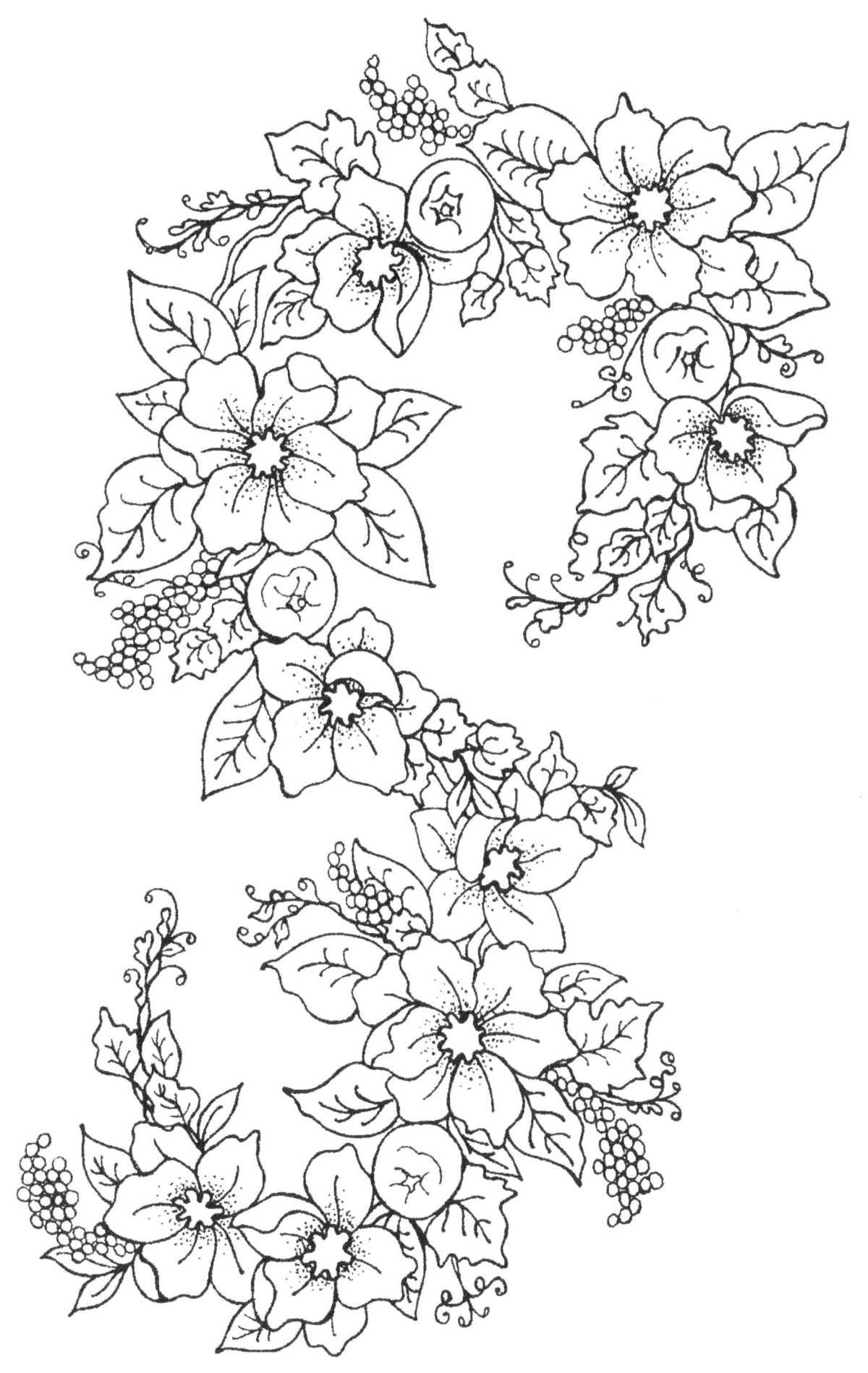

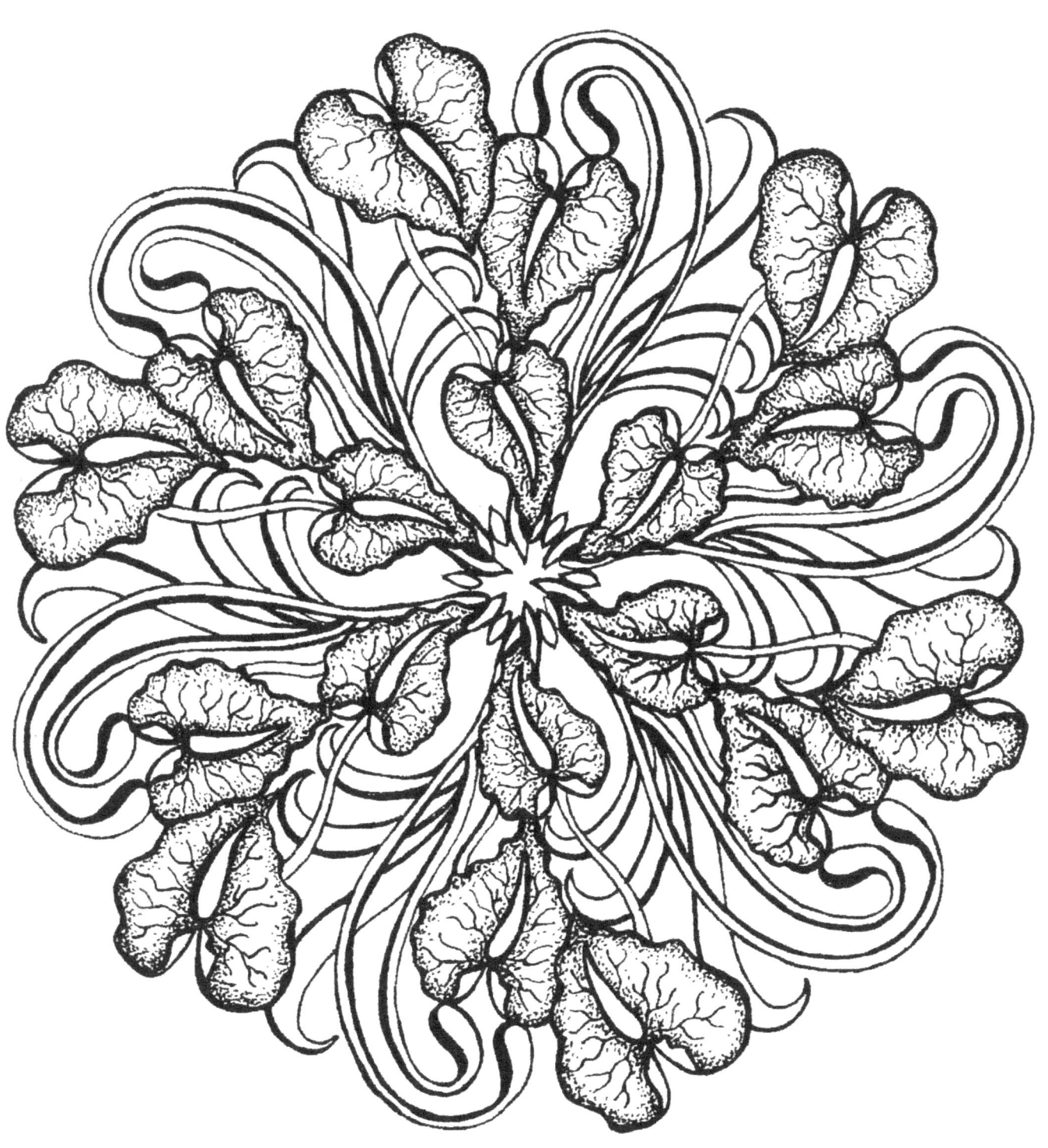

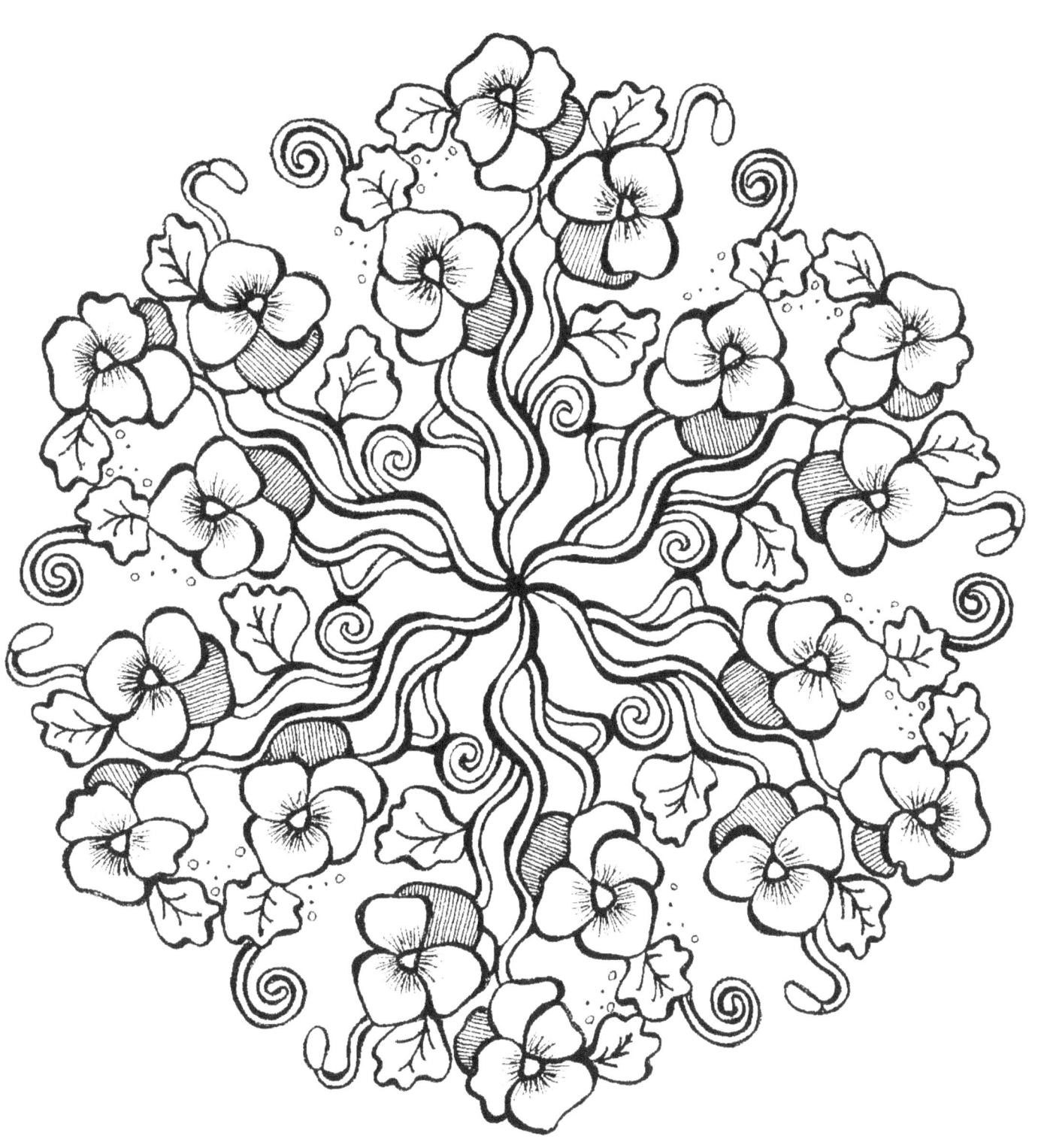

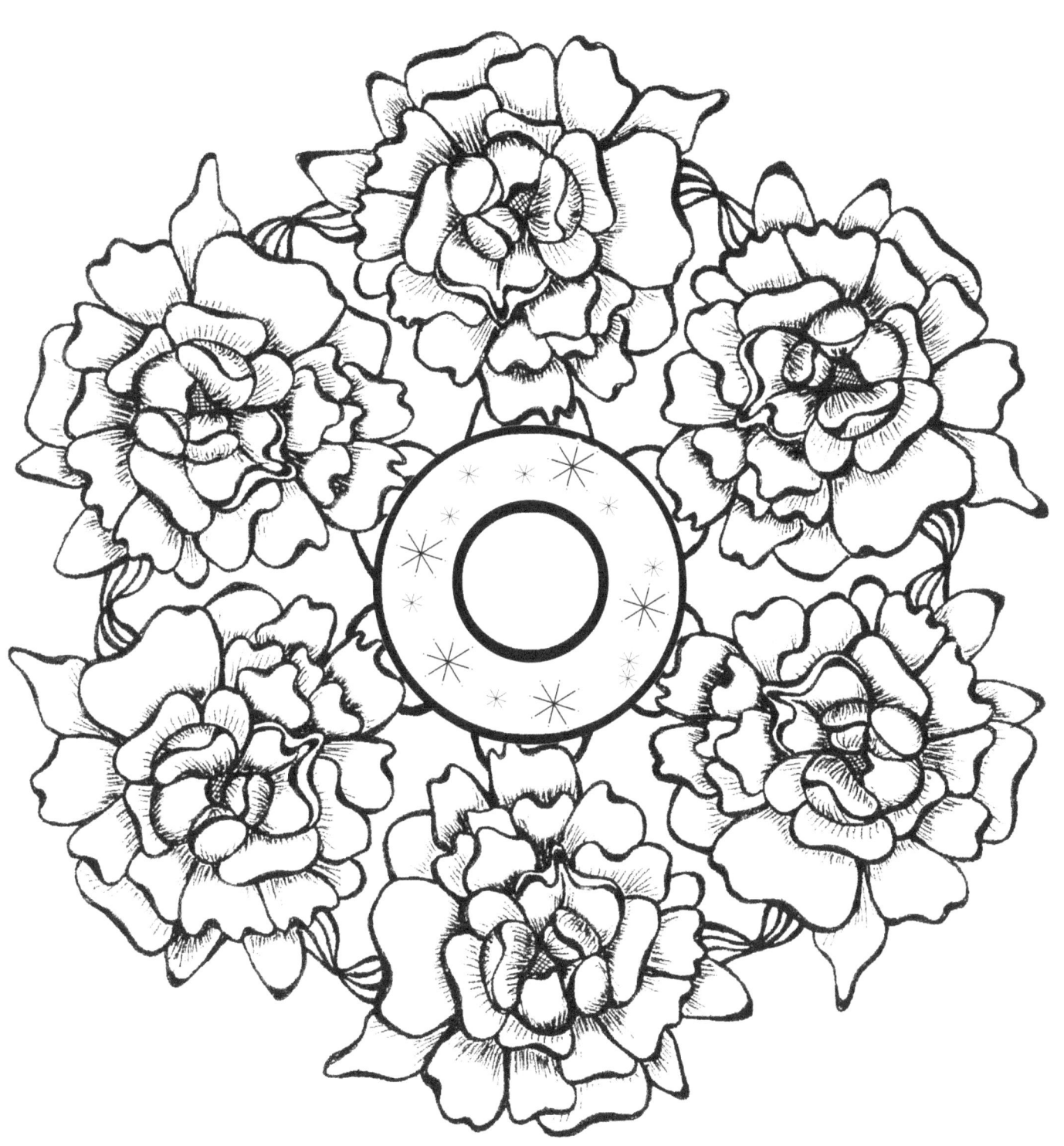

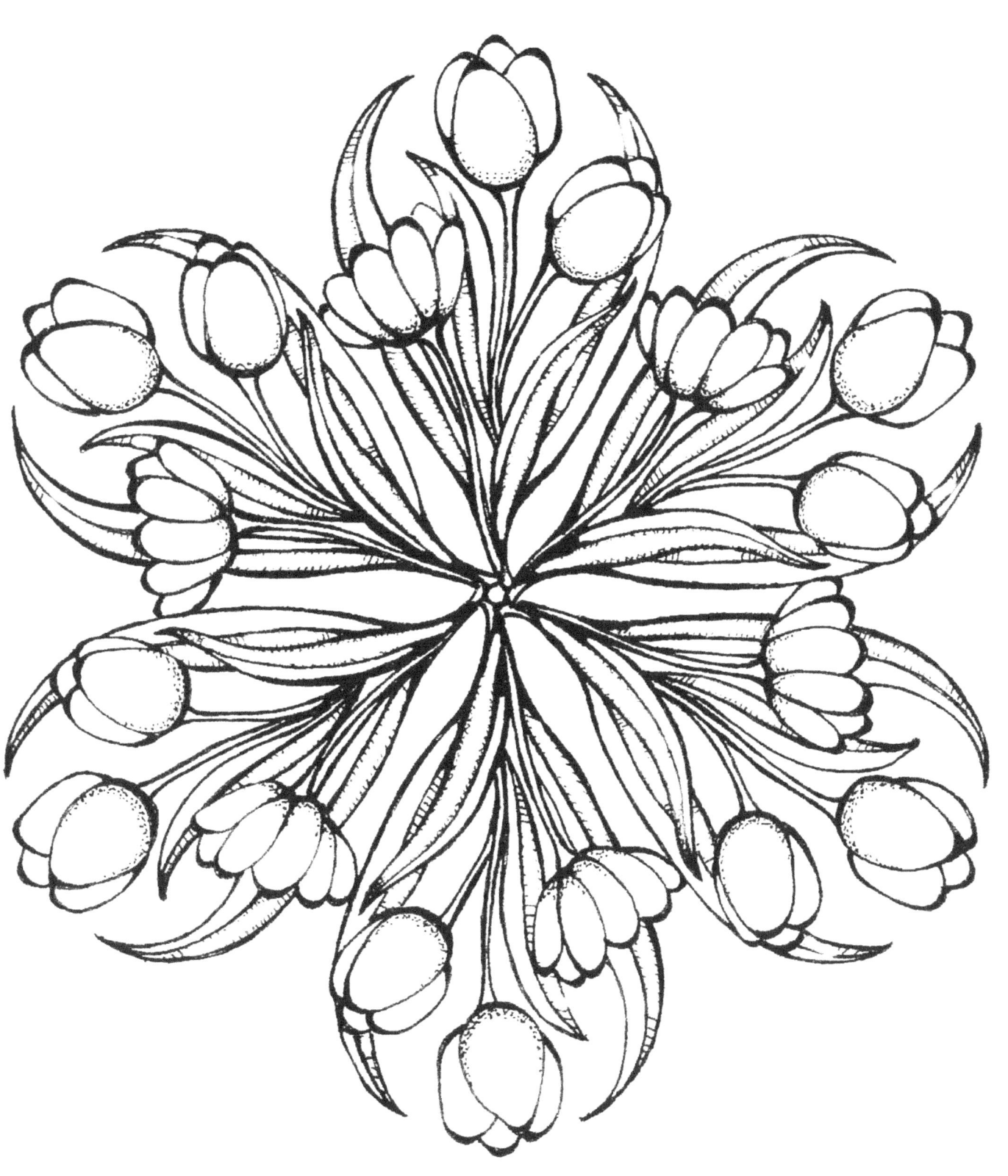

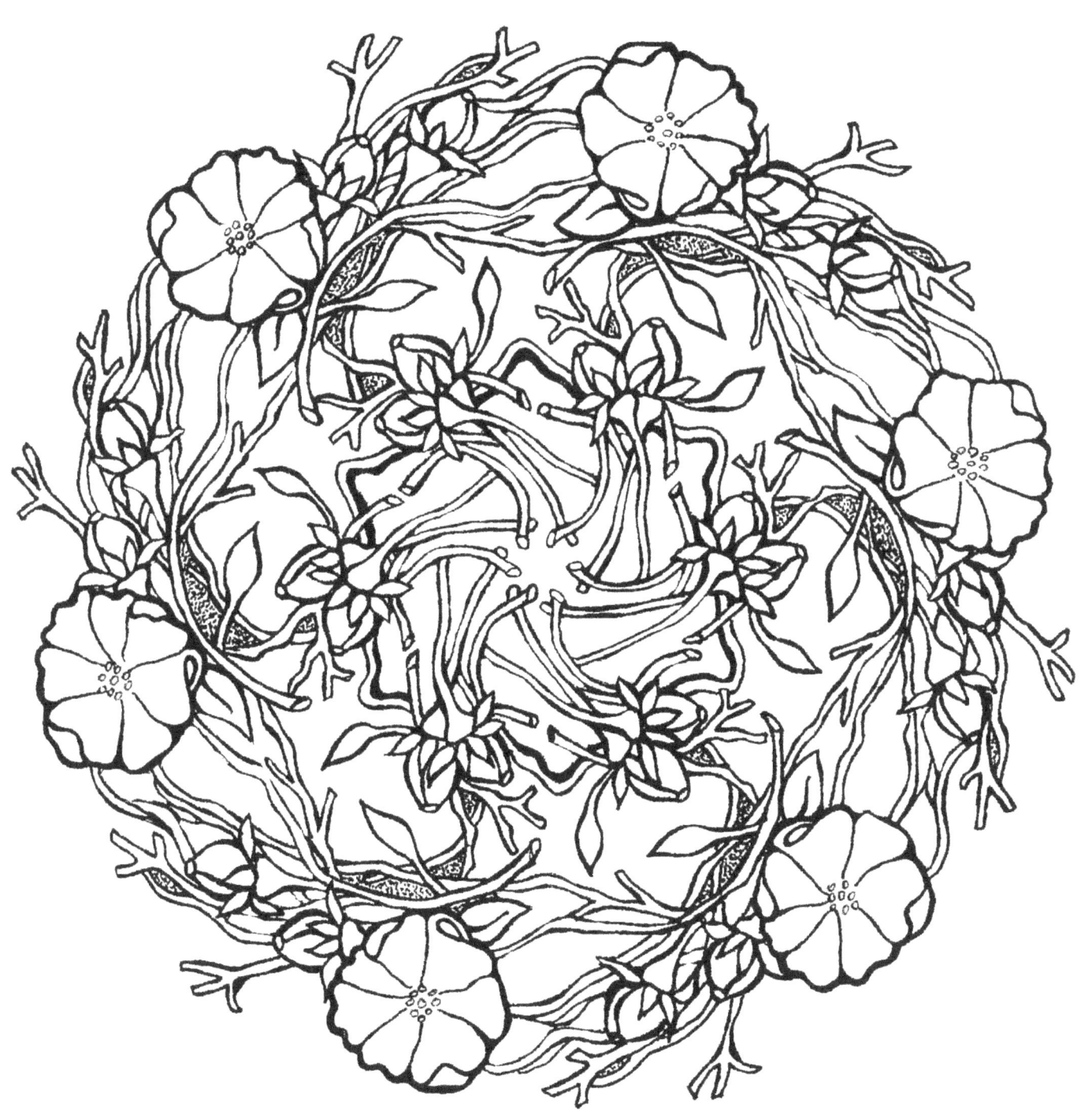

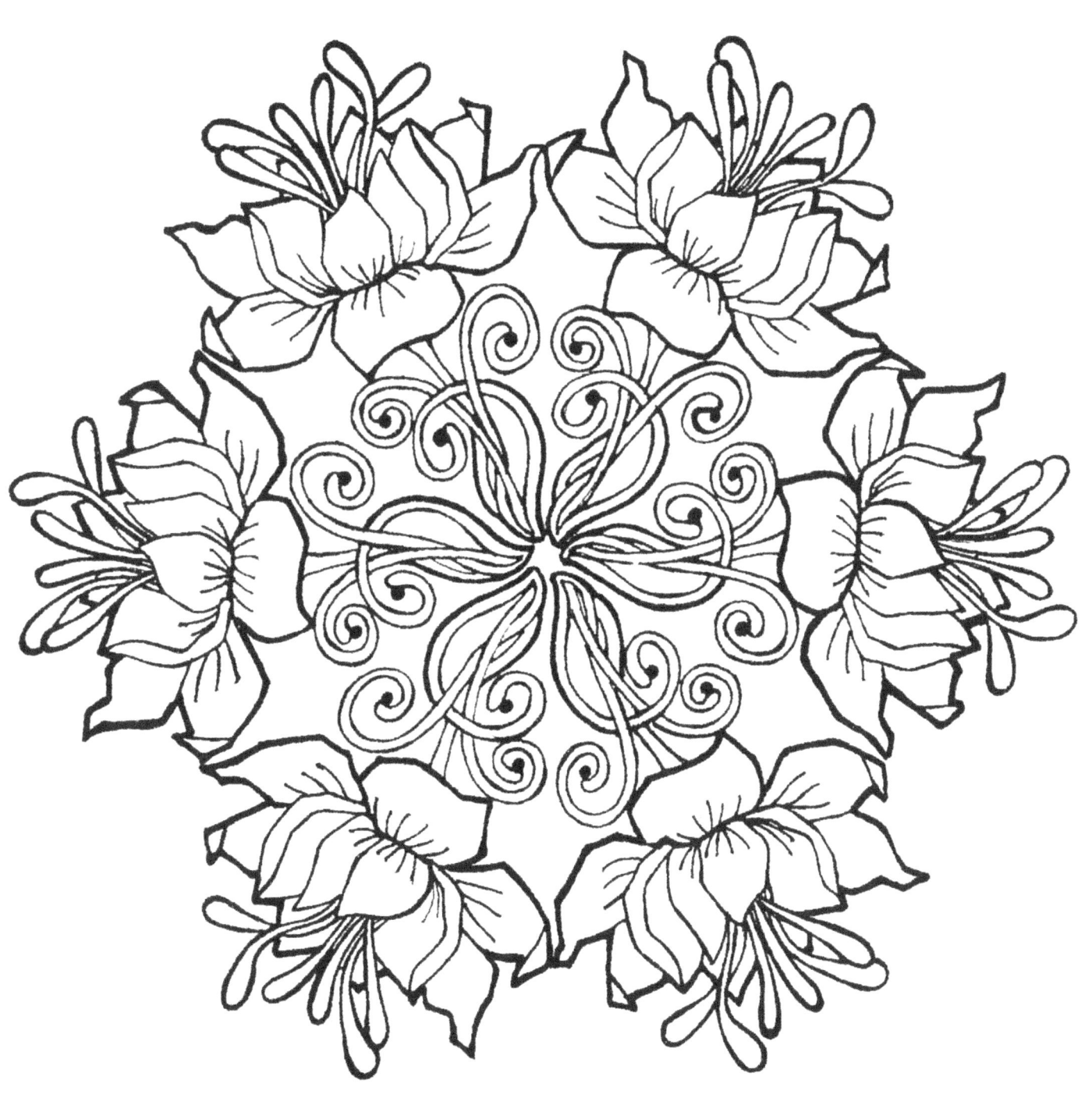

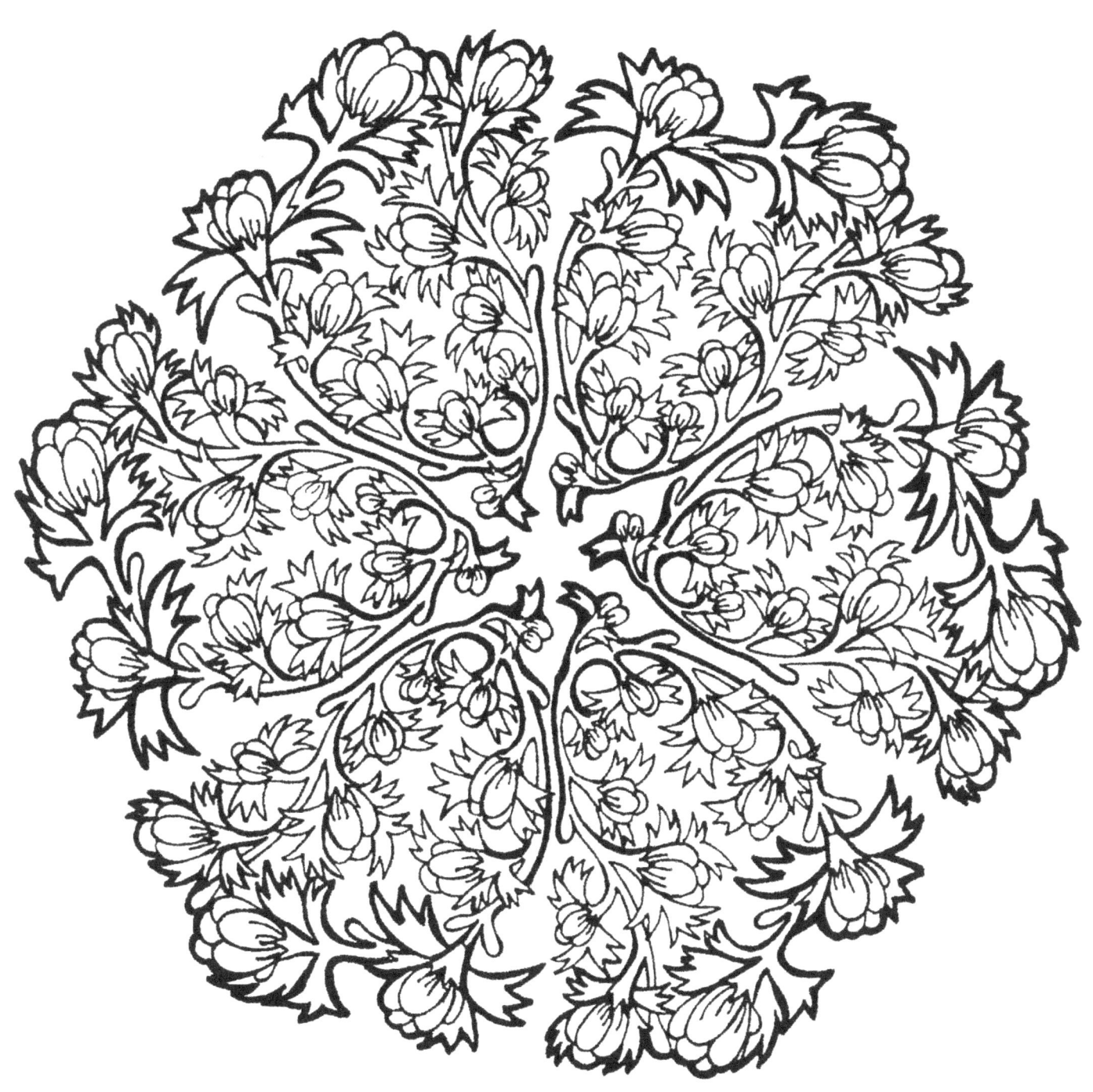

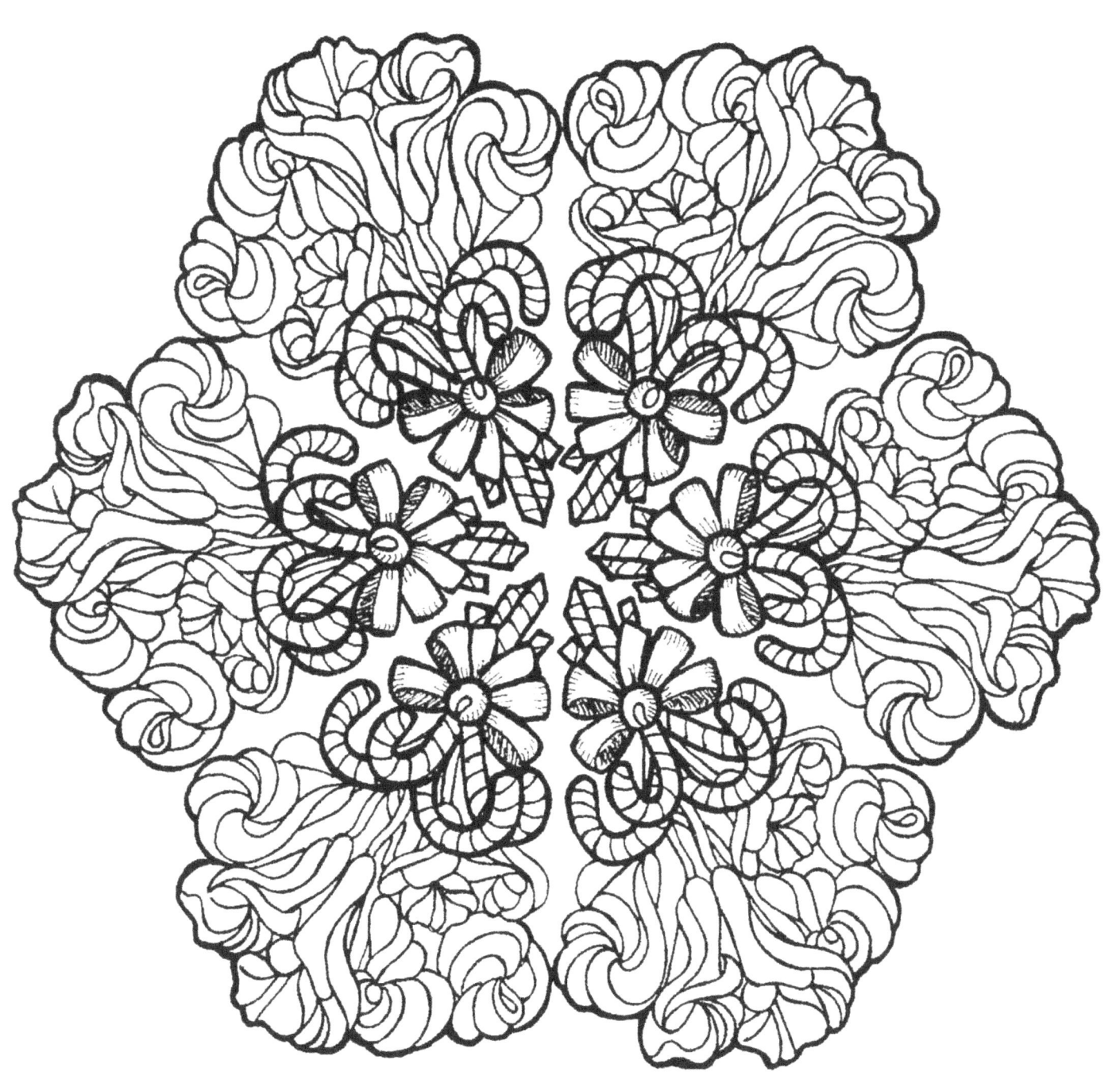

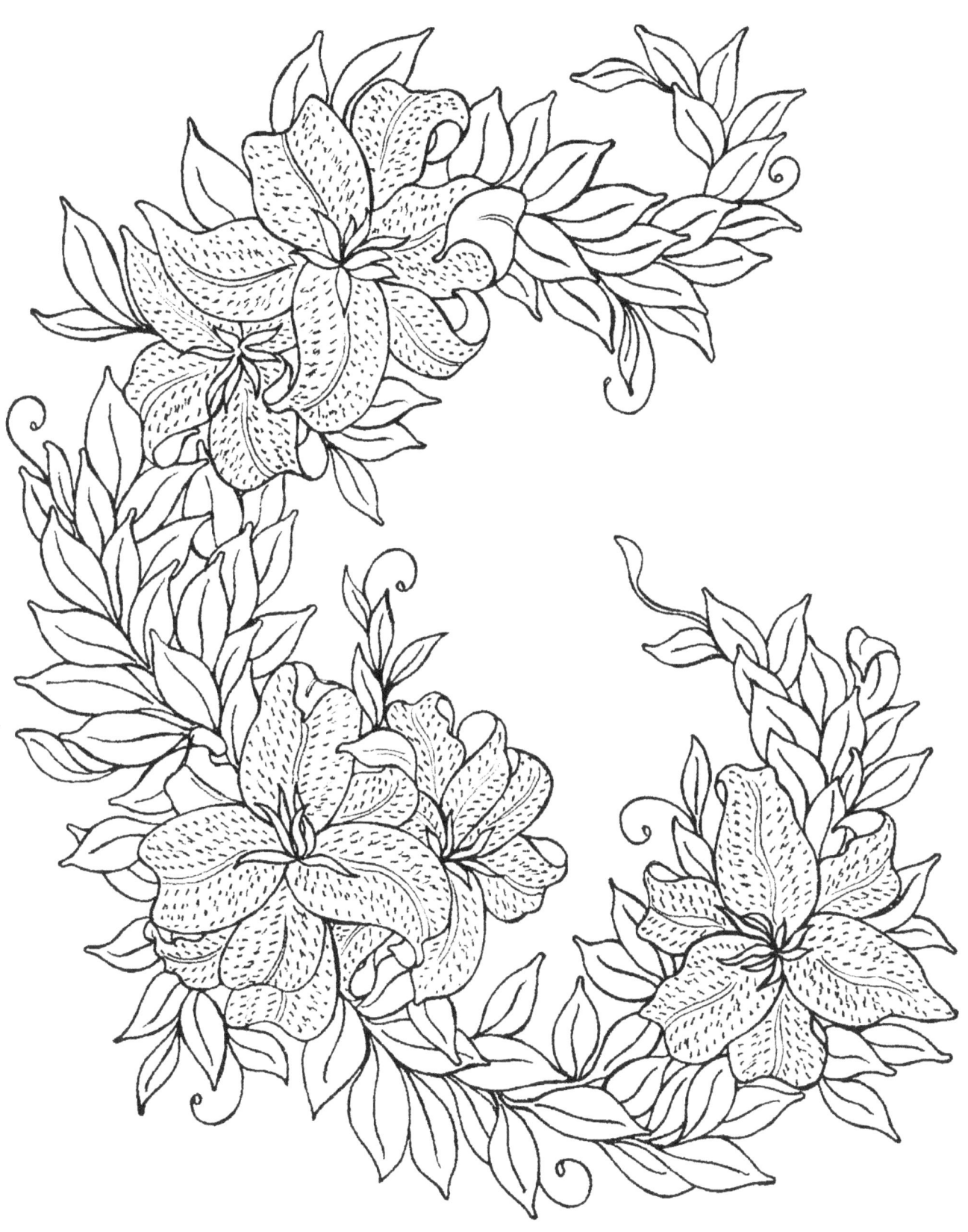

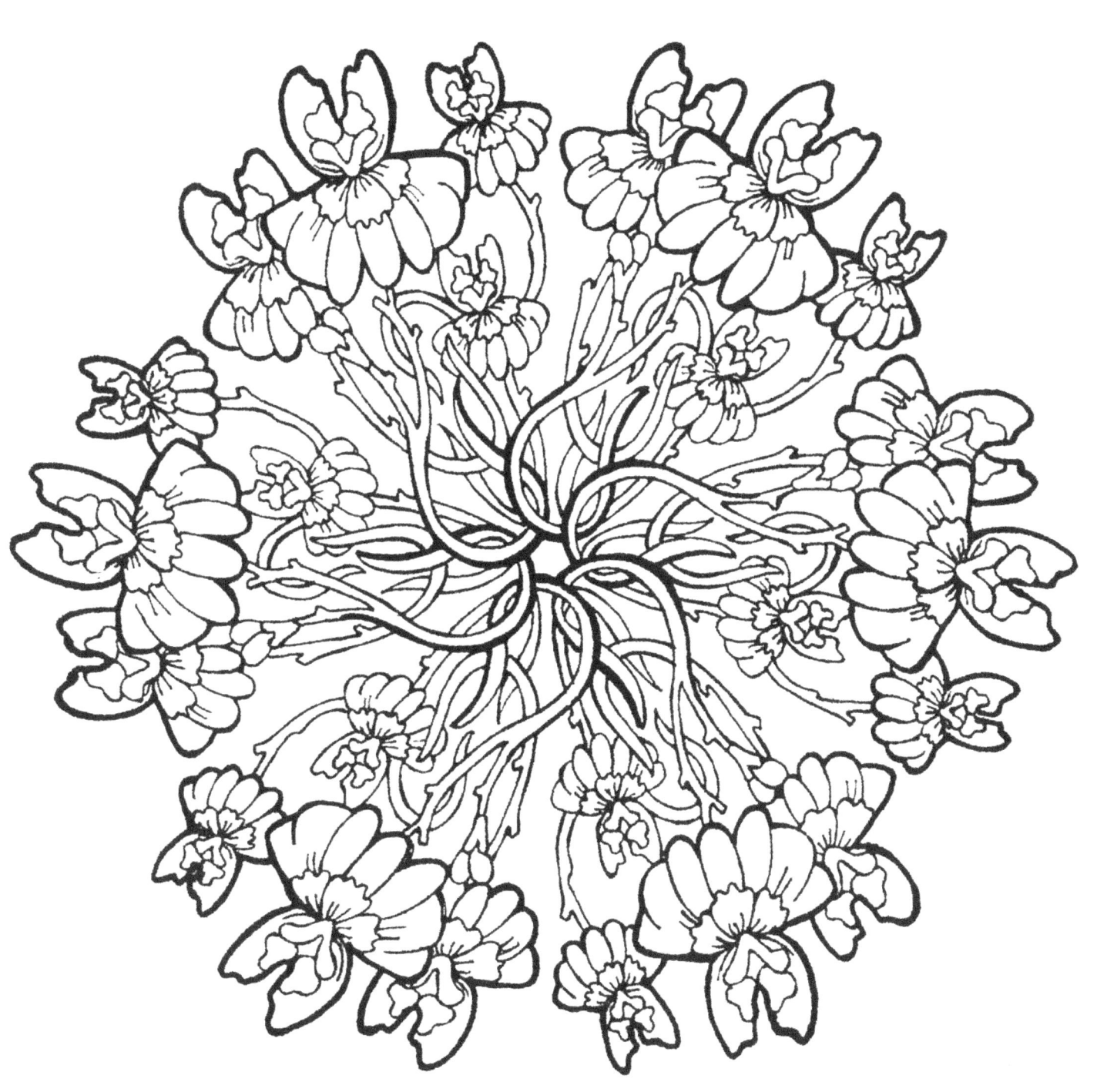

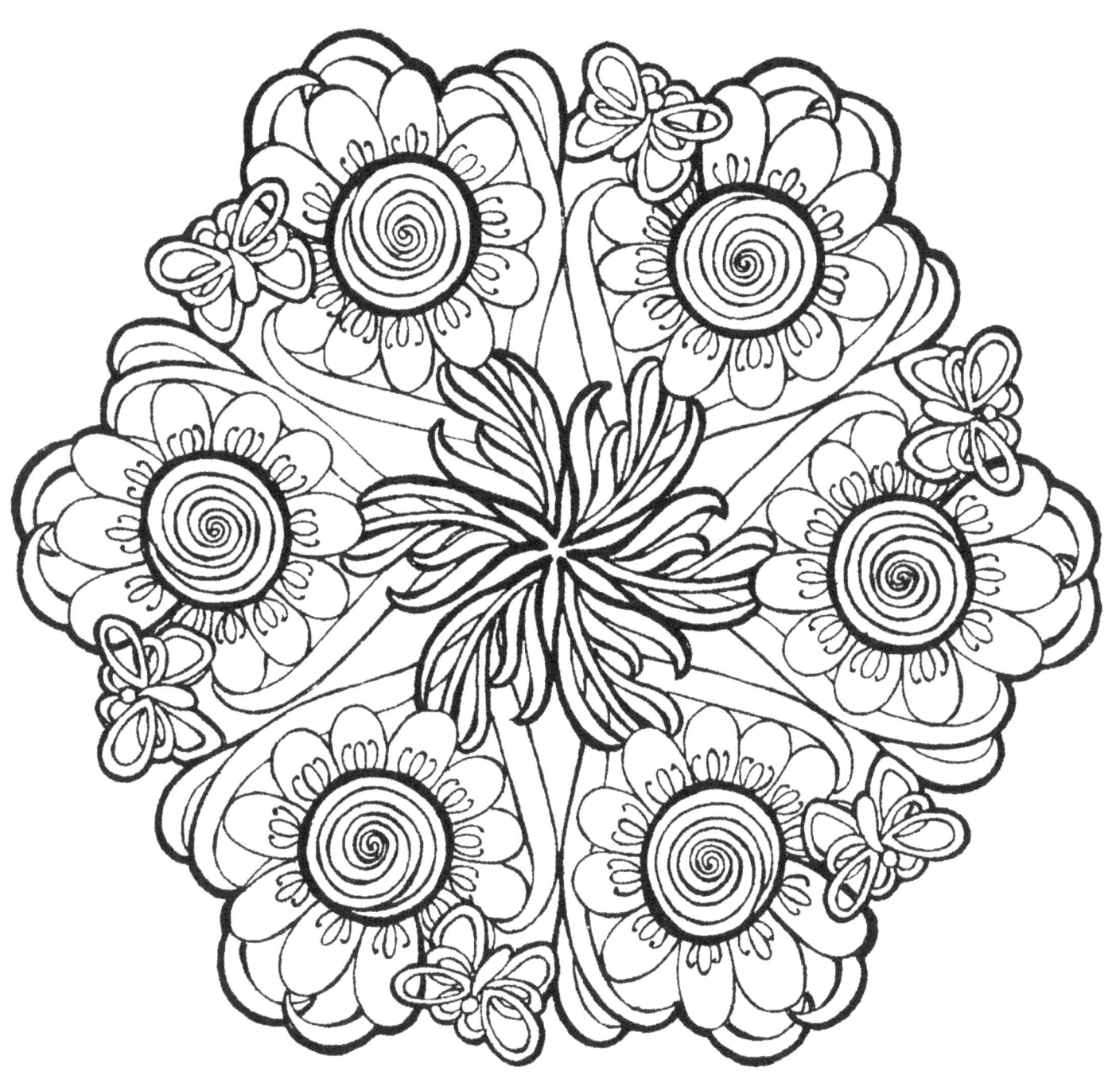

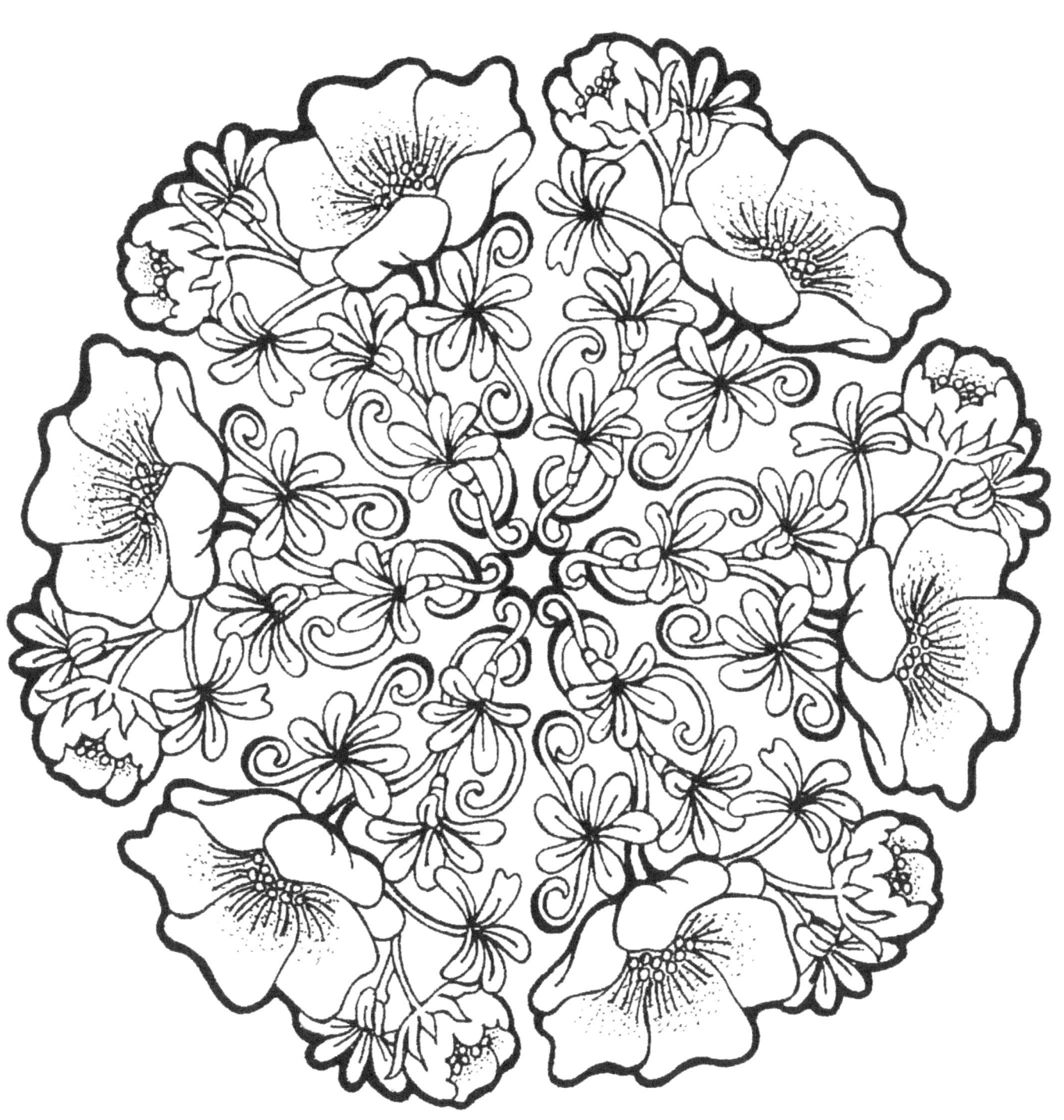

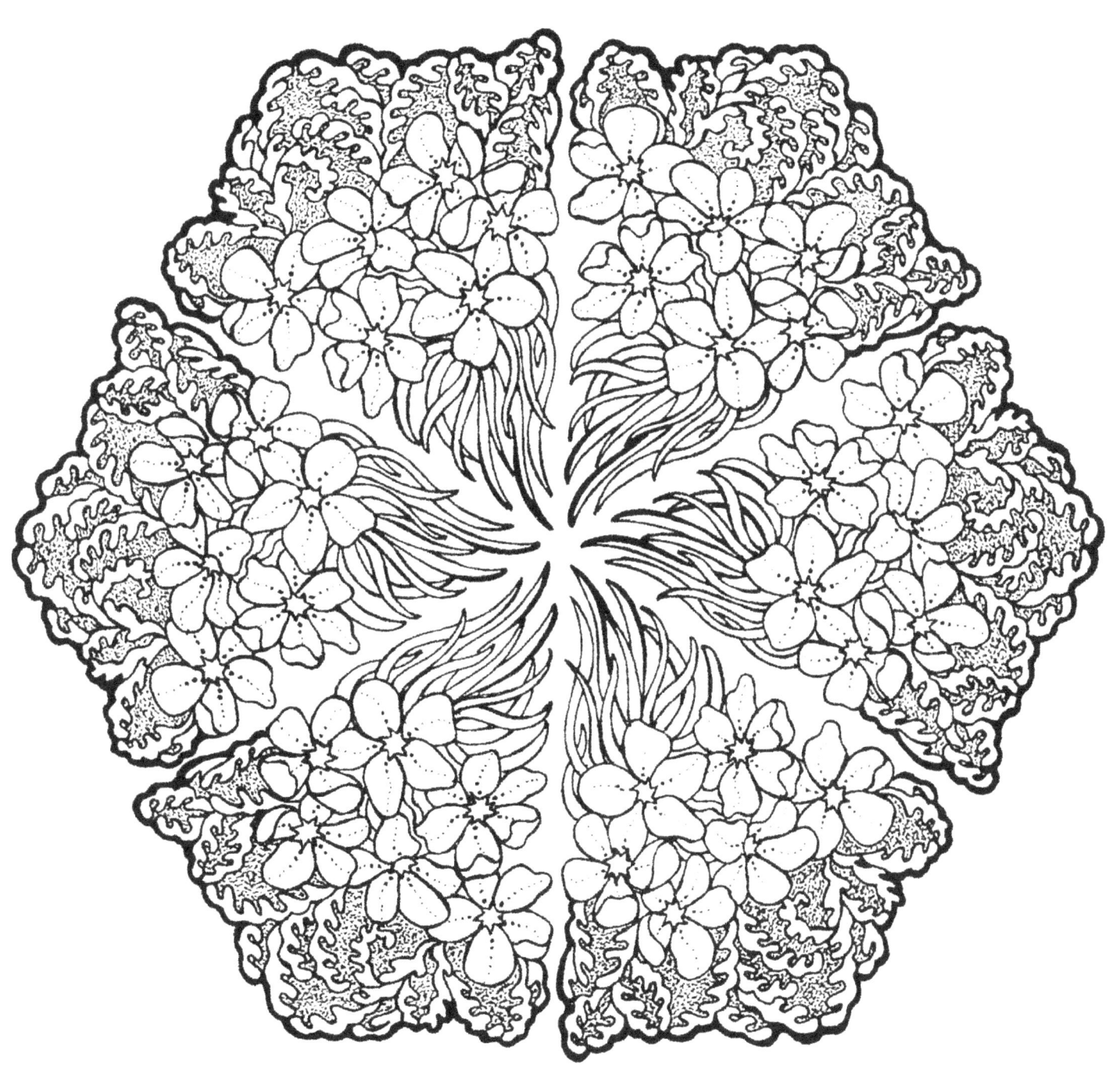

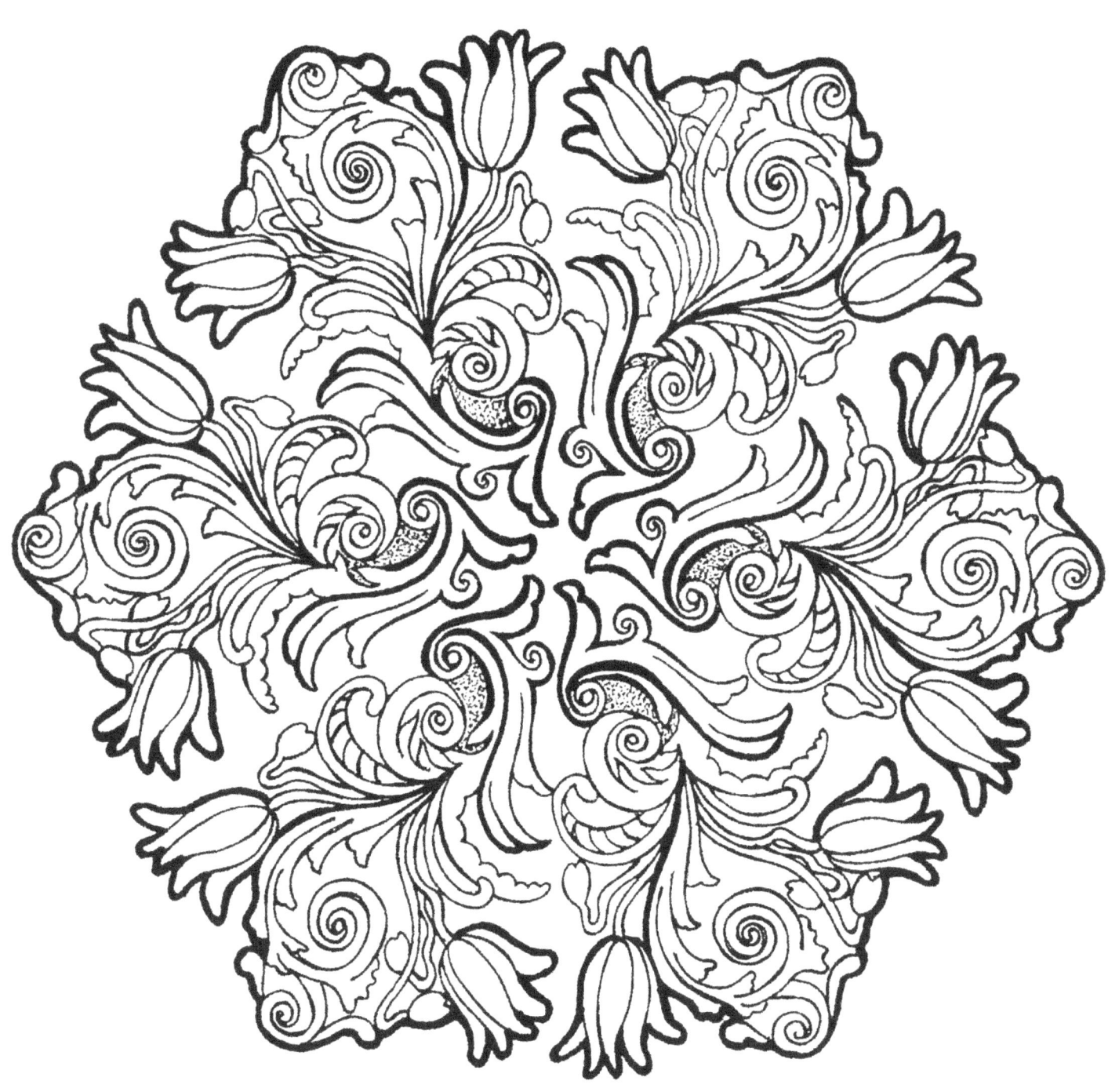

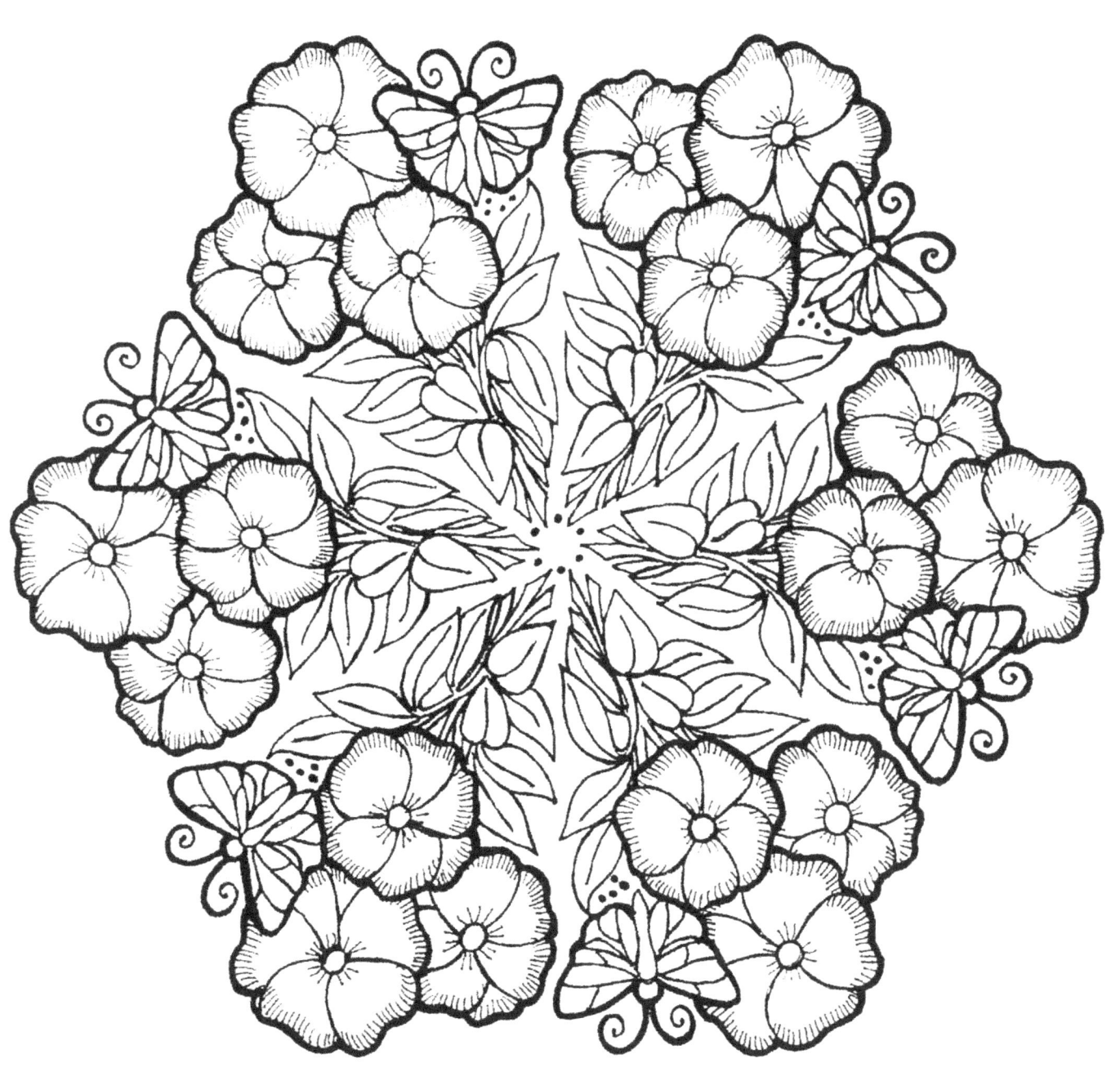

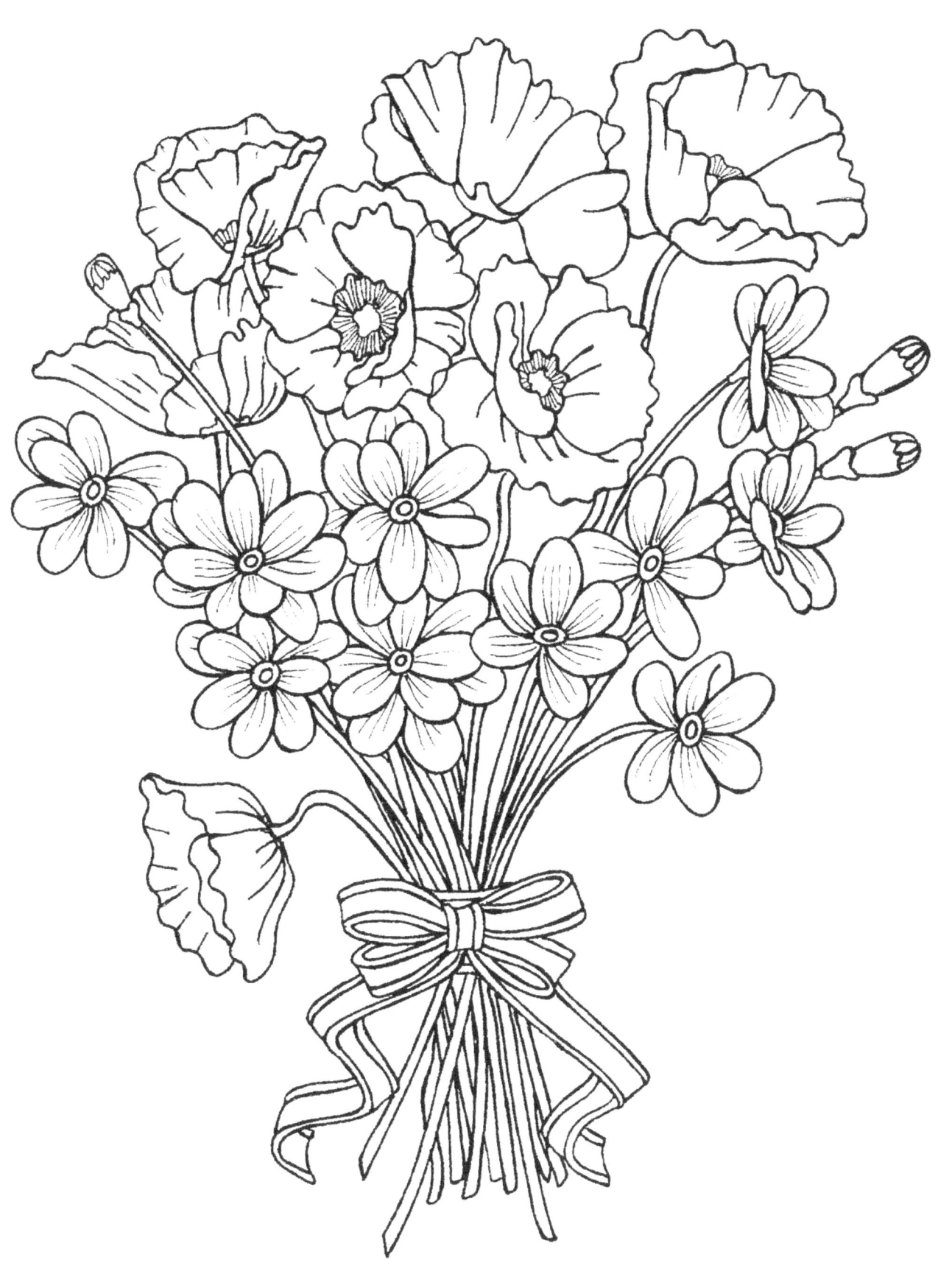

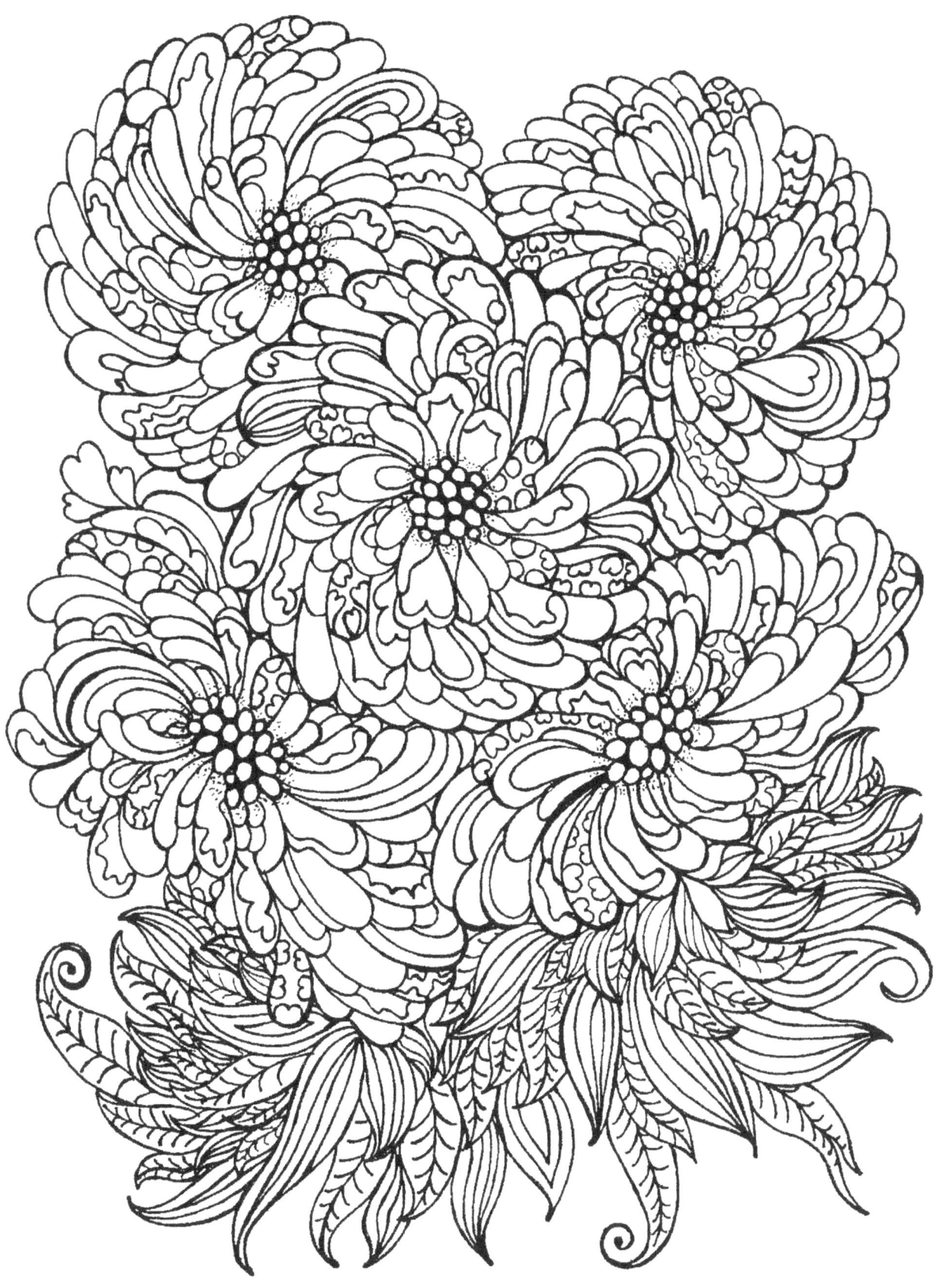

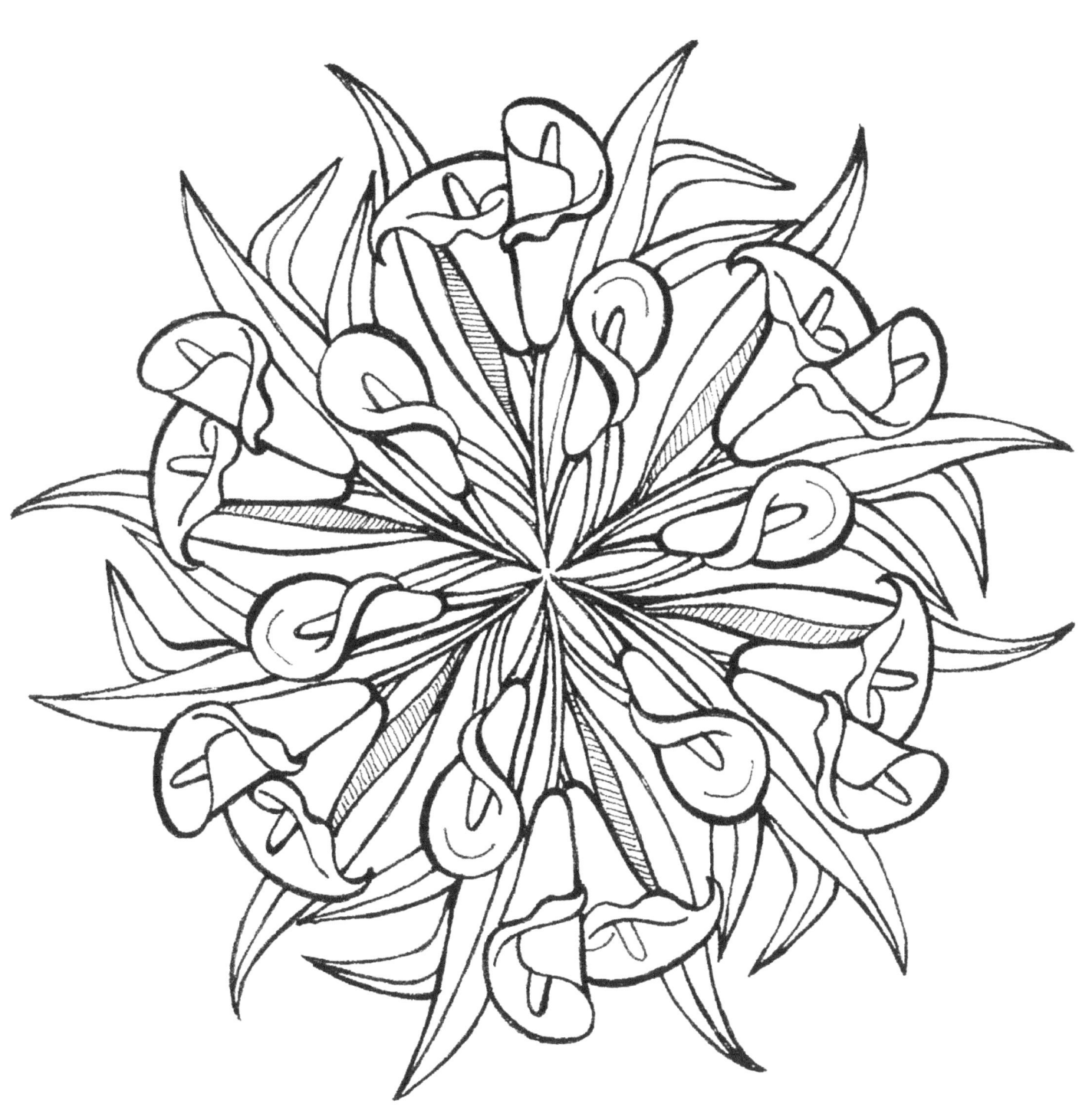

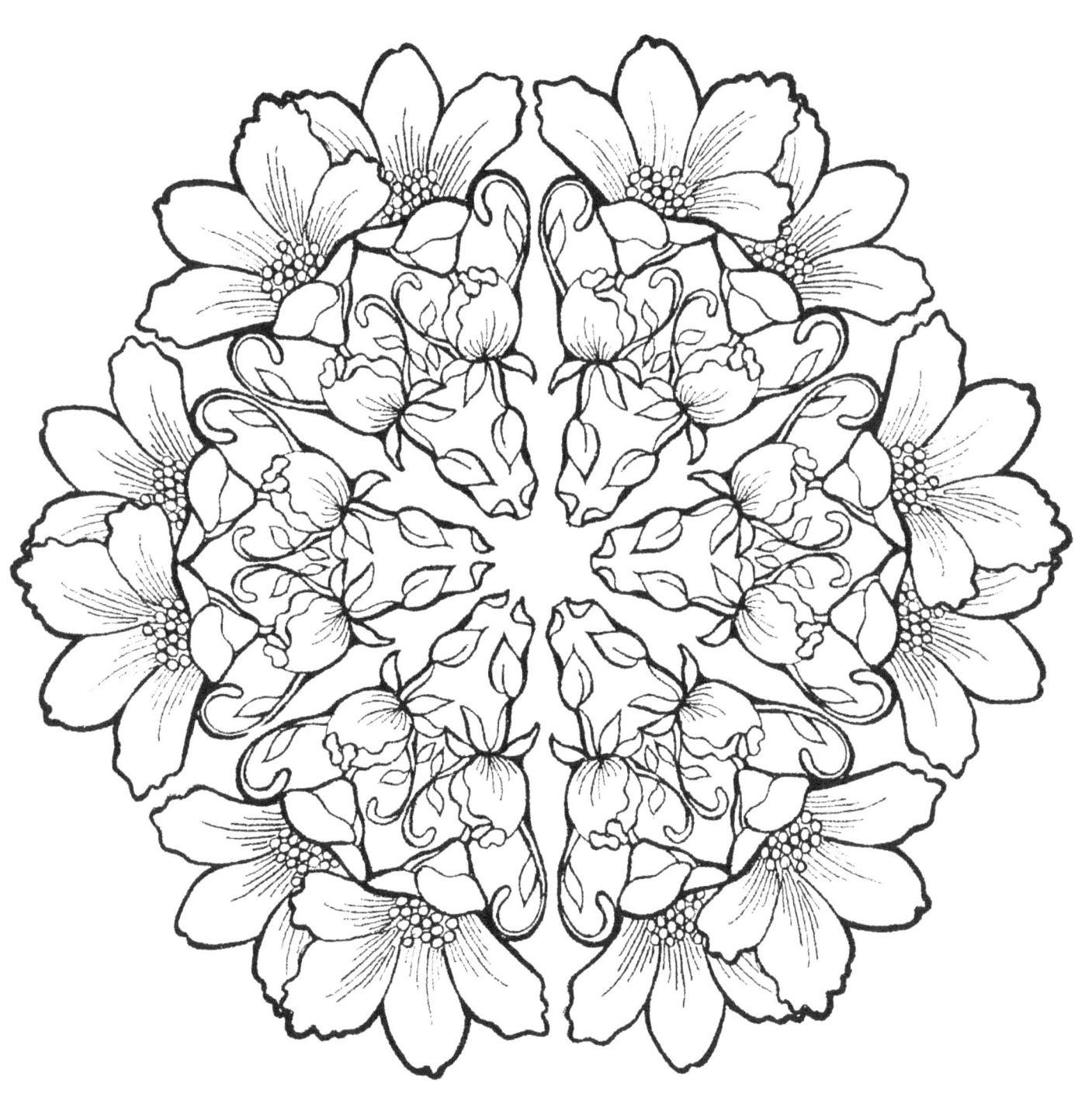

Artists

Sisters: Marie Scott & Dawn Andrus

In the shadow of Mount Baldy, in a humble cottage, Marie and Dawn learned to love the gifts of art, literature, and music by the bedside of their ailing mother.

When their mother died, they continued to love to sing, read, draw, color, and make enchanting paperdolls and cardboard box homes with imaginative furnishings.

The girls grew up, saw much of the world, had families, and have again come home and teamed up to spin their own world of magical fun drawing color books in Saxon Alley--not that far from old Mount Baldy.

Marie and Dawn hope to share the fun of their Saxon Alley coloring books with anyone looking for a little reprieve in this troublesome world.

To learn about their other coloring book titles, visit: saxonalley.blogspot.com.

For more information and inspiration, visit our blog: saxonalley.blogspot.com.

Watch for our other coloring books;

- Celtic-Inspired Snowflakes
- Dragon Snowflakes
- Whimsical Snowflakes
- Magical Flowers & Fairies
- Heart Charms

Order our coloring books on Amazon.com

www.ingramcontent.com/pod-product-compliance
Lightning Source LLC
Chambersburg PA
CBHW080538190526
45169CB00007B/2552